The Wedding Photographers' Book of

Contracts, Policies, Procedures

incite!
publications

Steve Herzog

**The Wedding Photographers' Book of
Contracts, Policies, Procedures**

Steve Herzog

incite! publications
1809 Central Avenue
Ceres, CA 95307-1806
209/537–8153 (phone)
209/537–7116 (fax)

This publication is designed to provide accurate and authoritative information in regard to the subject matter covered. It is sold with the understanding that neither the author nor the publisher is engaged in rendering legal, accounting, or other professional service. If legal advice or other expert assistance is required, the services of a competent professional person should be sought.

From a Declaration of Principles jointly adopted by a Committee of the American Bar Association and a Committee of Publishers.

Printed and bound in the United States of America

ISBN 0-9633158-3-8

Introduction

If you've been doing weddings for awhile, you know there's more to successful wedding photography than just the pictures. When you start talking about *making money* with your photographs, you've got an entirely different set of skills to master besides the posing, lighting, equipment, and special effects.

Those skills are *business* skills—and, in many ways, learning to effectively manage this side of professional wedding photography is more important than the photography itself. If you plan to build a profitable, respected, and *enjoyable* business, then you literally have no choice but to merge your picture-taking abilities with a system of policies and procedures which coordinates everything about your operation, and keeps it on track.

That's easier said than done. But, it's not an impossible dream.

Far from it. A strong policies system really can be developed overnight... and put firmly in place within a few days. Best of all, you don't have to learn by trial and error. Others have traveled this road before you. The ideas and information you need are available simply by reading how these photographers handled the same situations you're investigating now.

That's precisely what you'll be doing over the next 76 pages. With this book, I'll be outlining the wedding systems built, tested, and fine-tuned over the last 20+ years here at my studio. By the time you're done, you'll have a framework of contracts, policies and procedures that should make your job as a wedding photographer more enjoyable, more profitable—and a lot more organized.

Weddings *Should* Be Fun!

Contrary to the way some photographers talk, weddings should *not* be a hassle. It's an exciting time for your clients, and it should be *fun* working with these excited people on this most important of days. It's unnatural for it to be anything less than a great day for everyone involved. Including you.

That's going to be the assumption from this point on: that you want your weddings to be fun on a personal level, *and* profitable as a business. You want to enjoy yourself, and make money at the same time. Plus, you want your brides to enjoy the entire process of working with you, from the time they first meet with you before the wedding, until the final pictures and albums are delivered months later. You want your brides to enjoy writing those checks, and be thankful they selected you as their wedding photographer.

That's the way it should be. That's natural.

What you *don't* want is for an otherwise fantastic wedding assignment to crash and burn because you and the bride got upset with each other over some minor point or misunderstood policy. When *that* happens, it can take all the fun out of weddings—and extinguish profits.

Contracts and Policies: Mandatory Equipment

The best way to avoid misunderstandings, large and small, with your brides is to anticipate where the flare-ups will occur, then move quickly to douse those hot spots *before* they get out of control. Since you're the professional in this situation, you're in charge of setting up the systems that will ensure everything relating to the photography goes smoothly, and as planned.

To get the job done, the best tool available is the fireproof *wedding contract*, which lays out, *in writing*, the ground rules for each assignment. This one piece of paper can, almost single-handedly, wipe away many of the communications problems you may now be having with your brides.

A strong contract accomplishes all of the above in two ways:

• *Educates the bride.** A wedding contract is, more than anything else, a vital *communications link* between you and the bride. It defines the way your business works, your policies, and what you expect from the bride. Equally important, it also spells out what the bride can expect from you.

• *Protects your rear.* In a situation as emotionally charged as a wedding, there's a lot of room for misunderstandings and crossed wires. Without a

*Throughout this book, I'll be speaking in terms of "the bride". I've heard rumors that an occasional groom gets involved in the process; more likely, it's the bride's mother. No matter. For the sake of this discussion, these parties will be lumped together as "the bride". After all, it is "her day".

contract, when an assignment starts to short-circuit, it's you who will get burned…unless you have a contract in place, and backing you up. Think of it as a fire insurance policy for your business, because it is.

For these reasons, plus all the others that we'll discuss in this book, a contract should be a mandatory part of your wedding equipment list. It's crazy to even think of going to a wedding without one.

Something To Point To

No matter how good your contract, or how carefully you've gone over each point, there will still be those inevitable instances where you and the bride interpret things differently. You *know* you said one thing. The bride is *positive* you said another. There's no way of escaping this fact of business life.

But there are ways to minimize the damage. All it takes is a clearly defined set of policies written down on a signed contract, and your finger. When the bride raises her question(s), don't get into a verbal brawl. Instead, get out your copy of her contract, then use your finger to point to the relevant policy, and say, "This is what we discussed, and what we both agreed to, when you first asked me to be your photographer. It's the way we handle this situation with all our weddings." As long as your policies are fair and reasonable to begin with, most brides will accept your interpretation. You'll be amazed at how effective this "pointing to the signed contract" approach is in defusing problems, without causing lasting damage. Instead of forcing your viewpoint on the bride, and getting yourself into an argument you can't win, you'll reach an amicable agreement to do things as you both earlier agreed. And, you'll still be friends.

Laying the groundwork for your own contract will be the subject of the first two chapters in this book.

Procedures: Automating The Details

Having an industrial strength, all-purpose contract is a great place to start, but it's not enough. Even fail-safe contracts and policies can't operate in a vacuum. There's the matter of *execution*: organizing and coordinating all of an assignment's many details, so you can uphold your end of the contract, and deliver your product as promised. If you plan to keep these promises, and do it with a minimum of screw-ups, you need to be more than a little organized.

Staying organized is not as difficult as you might think. The task is made easier by the fact that while each wedding is indeed unique, 95% of the behind-the-scenes work follows a set routine. The faces and poses vary from week to week, but from a purely mechanical standpoint, the steps involved faithfully repeat themselves from one assignment to the next. All start with collecting information, booking the wedding, delivering proofs, collecting orders, and eventually delivering the finished orders.

This repetitiveness makes these steps prime candidates for *automation*. This means setting up a system of forms which march you, step by step, from one stage of the assignment to the next. These forms may not be as mission-critical as your primary contracts and policy forms, yet on a day-to-day basis they'll make your job a heck of lot easier by taking some of the load off your over-worked brain.

You'll be relieved to know that you don't have to reinvent these forms. In the third and final chapter of this book, we'll go through the set of forms which has evolved over the years at my studio. As with the main contract and policy forms, the forms which formalize our day-to-day procedures go a long way towards keeping my business on track and under control.

Problem Half-Life

Now that I've whetted your appetite for the wonders of ironclad contracts, solid policies, and automated procedures, does that mean that from this day on all your weddings will be blissfully *perfect*?

Sorry to say, this is not the case.

What I can tell you, is that once you're up to speed with some (or most) of the ideas in this book, you'll quickly see that the amount of time you're spending battling problems will go down—and those problems that remain will be much more manageable.

My rule of thumb is this: I don't expect my web of contracts, policies and procedures to snare every problem. I realize I'll never see a year's worth of *perfect* weddings. Instead of thinking in terms of totally *eliminating* problems, I've made it my mission to cut the current count by half—then by half again. And again! I'll be content with minimizing problems and getting them down to, say, .1% of where they were before I started using my "system". I can live with that.

I enthusiastically recommend that you adopt the same line of reasoning. Take what you need from this book, adapt it to your own situation, execute well—and then keep fine-tuning until you've reduced what were once common problems into the uncommon, unavoidable, but manageable, few. Turn a few of those mountains into molehills. You can deal with molehills.

That said, let's get started. We've got a lot of ground to cover.

1

The Wedding Contract: Terms of Endearment

You know the routine:

The bride hits your front door with stars in her eyes. She *knows* her wedding is going to be picture perfect—which means that once she hires you, she expects to be presented with an album of perfect pictures. It's going to be a wedding made in heaven.

Then all hell breaks loose. In short order, what should have been a smooth, friendly, straightforward business relationship deteriorates into a photographic version of the shoot-out at the OK Corral. The bride is sniping at you, you're firing back with threats. Things are not OK.

What happened? Chances are, there was a failure to communicate.

Rule of Law

In most cases, the hassles between photographers and their clients start out as simple, honest misunderstandings. You say one thing, the bride remembers another. The bride wants to do it her way; you remind her she'd agreed to do it

yours. From your standpoint, there is no way to "win" these arguments. At the least, they are a distraction. At most, they can cost you the order and the good-will of the people your business is dependent upon to grow.

Protecting Yourself—And Your Reputation

There's only one way to ensure that you and the bride are playing by the same rules—you've got to have a formal, written, non-verbal *contract*. A smile and handshake aren't enough.

All the reasons for using a contract boil down to one simple idea: a good contract helps you and the bride understand each other. It's the best way you've got of getting your vital business information into a bride's hands, and getting her assurances that it's understood.

Where many photographers get into trouble is by assuming all brides understand, and will remember, every statement/policy/concept that the photographer utters. If you've ever had a bride go ballistic over a misunderstood policy, then you *know* you can't assume that just because you explained something once, that in five months she'll remember it word for word. Chances are she won't. And when she doesn't, it's you who pays the price.

Start With What You Know

To get the contract-building process started, your first task is to make sure *you* understand what you're trying to accomplish. You need to think through all the steps involved in a wedding, decide what you want to have happen, and come up with rules both you and the brides can live with. You need to nail down promises, prices, payment schedules, policies, etc. It's up to you to make these initial decisions.

Next, you need to take this list of ideas and write them down. They need to be presented in such a way that they're easy for you to explain, and clear enough for the bride to understand without calling Perry Mason.

Contract-building is really not difficult. If you've been doing weddings for awhile, you already have a system of policies and procedures in place. It may be verbal and very informal. It may not be totally consistent. But it's there. It exists. It's a place to start.

Now, all you have to do is formalize it, polish it to get rid of any rough edges, and put it down on paper.

A Two Part Contract/Policies System

In my business, I've gone through this process...many times. I've borrowed ideas from other photographers, added a few of my own, and mixed everything up into my own custom contract blend. There's been a lot of trial and error, but even the missteps have taught me valuable lessons. The end result: I now have a

contract which helps me avoid problems, keeps wedding assignments running smoothly, and makes it easier to stay on good terms with the people paying me. It's been worth the effort.

It's this contract we'll use as the basis for our discussion in this book. The contract is actually divided into two separate, but equal, parts:

> • The *Wedding Contract*, which lays out the firm, "non-negotiable" points I want to make sure are absolutely, positively understood *before* I commit myself to a wedding. These details make up the front side of the contract page, and they're what we'll be discussing in this chapter.

> • The *Policies Statement* is printed on the back of the contract page. It covers some of the same territory as the Wedding Contract, but from a different angle. The Policies Statement's job is to guide the bride through the assignment via a step-by-step chronology of what will happen from the time the wedding is booked, until the finished photography is paid for and delivered. (This will be discussed in the next chapter.)

My reasons for dividing the contract into two sections are to make it easier for the bride to follow, and for me to explain. I've seen contracts from other photographers which, paragraph after numbing paragraph, work real hard to include every point the photographer could think of—but make little attempt at organization *or* clarity. Not even a slick-haired city lawyer could understand some of these contracts, let alone an unsuspecting bride who is just trying to purchase hassle-free wedding photography.

If you agree that the contract's primary function is to help you avoid problems *before* they happen, then in your contract you'll want to do more than just toss something at the bride for her to sign. When a bride reads your contract, you want her to finish with the fewest number of unanswered questions possible—and you want it all to happen quickly, and cleanly.

The Wedding Contract
Line by Line

When you first meet with a bride, the *last* thing you talk about are contracts and policies. First on the agenda is the wedding itself: the pictures, the church, the flowers, etc. She's telling you how beautiful everything will be; you're telling her what a magnificent job you'll do capturing all of that—and more—with your camera.

During these talks, both of you are taking notes. You're jotting down the general information the bride is telling you about her wedding. The bride is writing down her impressions about you, your photography, your prices. She's sizing you up, just as she will every other photographer she interviews.

What you and the bride are doing, is getting a feel for what it will be like to work together. This exploratory phase comes to an abrupt end when the bride announces, "We've made a decision. We'd like to have you take our wedding pictures."

When that happens, it's time to back away from the chit-chat and get down to business. Both you and the bride need to establish basic ground rules for what is now an official business relationship. It's time to get down on paper everything you've been talking about. It's time to get out the contract, and start filling in the blanks.

Basic Information

Using the copy of my contract shown on the opposite page[*], let's go through all the points covered—and discuss why they are included on this *very* important form.

Names, Date, Day of Week

At the top of the contract are spaces for filling in the standard names, wedding date, starting time and location, etc. During your earlier meetings with the bride, you've no doubt been taking notes dealing with this same general information on others forms you use to track the bride's ideas about what will be happening at the wedding. Now, you need to transfer this information to the contract.

[*] The Wedding Contract, as well as many of the other forms shown in this book, are available in incite!'s **Wedding FormsPak**. These forms are presented in a "universal" format; all you have to do is add your name, address, and phone number, then have them reproduced. All references to Steve Herzog Photography have been deleted. (For more information on these forms, see the order form in the back of this book.)

Contract for
Wedding Photography

Steve Herzog Photography
"when the feeling is forever..." SM

Bride: __JOYCE BUCKNELL__ Groom: __PHILIP WEISS__

Wedding Date: __Nov. 15, 1997__ Day of Week: __SATURDAY__

Starting Time: __11:00__ am/pm Ceremony: __1:00__ am/pm Completion Time: __9:00__ am/pm

Ceremony Location: __ST. ANTHONY - MERCED__ Total Hours Reserved: __10__

Coverage Selected: __9 hR.__ Total cost: $ __2800.__ (plus tax) Price List #: __5/3__

Your selected Coverage includes:
__1 FREE HOUR__
__70 - 8x10 PRINTS in MONOGRAMED ALBUM__
__FREE 11x14__

We request that *Steve Herzog Photography* be our exclusive wedding photographer, and agree to abide by those policies listed below:

❖ We agree *Steve Herzog Photography* is authorized as the only professional photographer at our wedding, and that guests may take photographs only as long as they do not interfere with the photographer's duties.

❖ We understand all negatives and Preview prints are owned by *Steve Herzog Photography*, and are not included as part of the reserved Coverage. (Refer to the separate *Wedding Services Price List*.)

❖ We agree to the deposit schedule listed below. We understand our deposit applies only to the above date. *We also understand the deposit is non-refundable.*

❖ We understand the prices quoted apply only if deposits are paid on time, and orders placed as later agreed upon. If not, the prices used for our order will be those in effect at the time of our wedding.

❖ We understand all photographs from *Steve Herzog Photography* are copyrighted, and may not be copied in any manner. We agree all prints from these photographs will be ordered only from *Steve Herzog Photography*.

❖ We understand *Steve Herzog Photography* will do everything possible to ensure the successful completion of this assignment. We agree liability is limited solely to the refund of deposits.

❖ We understand no finished prints or albums will be delivered until the full balance for all photographs ordered from our wedding has been paid, and that there can be no partial deliveries.

❖ We further agree to abide by the *Financial Arrangements & General Procedures* listed on the reverse side of this *Contract for Wedding Photography*.

We agree to the above:

Signature: *Joyce Bucknell* Date __5-4-97__

Studio Representative: __Steve Herzog__ Date __5/4/97__

Schedule for Deposits & Payments:

❖ A deposit of one-half the selected Coverage is required to reserve your wedding date. (No dates are promised or reserved without this deposit.)

❖ The second deposit of the remaining balance is due one month before the wedding.

❖ If, at the wedding, additional time is added to the selected Coverage, payment of the additional balance is due upon delivery of the Previews. (Refer to *Wedding Services Price List* for specific rates.)

Deposit received upon reserving above wedding date: $ __1400.__

Balance due no later than one month before wedding: $ __1400.__

Please be sure of your wedding date and plans before paying deposit. Deposits are not refundable.

© 1995, shp

The *Wedding Contract* formalizes the agreement between the bride and photographer. It lists "non-negotiable" policies, spells out who is promising what, then sets up the deposit and payment schedule. Our Contract is printed on 3-part NCR paper, using deep blue ink.

What you're doing here is locking in the bride's *final* choices out of all the options the two of you have discussed. The bride has told you she's *positive* about the date, time and location of the wedding. She's made her decisions about which of your coverages she wants to purchase, how much time she'll need you to stay, etc. She's given you the address and time where the photography will start.

These details may seem obvious, yet by taking a few minutes to add them to the contract, you're making sure each of you knows what the other is doing. You're also making it less likely that one of you will mis-remember an important fact because of a faulty memory.

You'll notice on my contract that there's a space to write down the day of the week. As with most items on all my forms, there's a reason for it.

You'd think that simply writing down the date of the wedding would be enough. Early in my career, and before I was using written contracts, I thought so, too. Then, I missed the first half of a *Friday* evening wedding because, in my mind, I had no doubt that wedding was on Saturday. I'll never forget that phone call I received at home, with the bride's mom asking, "The ceremony will be starting soon. Are you planning on coming to the wedding?" It was an embarrassing situation for me, and the bride lost out on some important pictures because of my screw-up. I never wanted that to happen again.

Ever since, and mainly for my own benefit, I've religiously written down what day of the week the wedding will take place. Protecting me from myself is an important function of my contract. One can never be too careful.

Reserving Specific Blocks of Time

Hours and minutes are a big thing with me. The pricing system I use now is built from the ground up around *time*: the total number of hours the bride wants me to be on duty and taking pictures. Each package I offer includes a specific number of prints, yet the decision of which package to select is based upon the hours elapsed between when I start and when I'm finished. Four hours? Six hours? Ten hours? With this system, it's all factored into my prices.*

Whether or not you'll need to track closely the number of hours you're needed depends upon how you book your weddings. Quite a few photographers promise the bride they'll "stay until the wedding is over". I used these open-ended coverages back in my early days, but I quickly grew tired of sometimes spending 12 or 14 hours at a wedding—most of it just sitting around, waiting. I wanted to be more in control of my own schedule.

* For a more complete discussion on using time as a powerful, and profitable booking tool, see my book, **Wedding Photography: Building A Profitable Pricing Strategy.** Chapter Four, "Controlling Additional Time" gives a complete outline of our approach. Price lists are shown which illustrate the wording used.

By listing both "Starting Time" and "Completion Time" on the contract, and combining that with how my price list is set up, I have done away with any questions about how long I am committed to staying at the wedding. If, for example, the bride wants me to start at 11 a.m. and stay until 5 p.m., then the "total hours reserved" is six hours. I now know *precisely* when I can go home—or move on to another assignment. There are no more disagreements with brides whose weddings are less than organized, and who decide late in the day that they need me to stay longer because they haven't kept to their schedule. If I can stay, I will; if not, I know, *and they know,* that I'm free to leave.

It's in the contract.

Coverage Selected, Price and Price List

Next on the agenda is writing down which coverage the bride has selected, the cost of that coverage, and on which price list that information can be found. This is nuts and bolts information, and you have to commit these details to paper.

Once again, the objective here is to avoid even the slightest chance that, over time, you or the bride will forget what was promised, and what the cost will be. This is not an area you want to trust to memory.

"Your Selected Coverage Includes"

Finally, the last pieces of information to write down in the upper section of the contract are a detailed list of exactly what is promised in return for the money the bride is paying.

It's always a good idea to be specific. In addition to copying from the price list what is automatically included in the price (the number of prints and sizes, for example) you should also note any special arrangements you've made with the bride. To book the wedding, maybe you offered to stay an extra hour at no charge. Or, maybe you said that if the bride booked the six hour package instead of the five hour, you'd give her a free 11x14. Whatever you promise, you need to write it down—especially the bonuses and extras.

Non-Negotiable Points

Once you and the bride have written down the specifics, it's time to move on to the next stop on the Wedding Contract tour: the policies the bride must understand, and agree to, before you'll make your final commitment to photograph the wedding.

Just as the bride has the right to set her own "minimum requirements" for the photographer she hires, so is it wise for you to do the same when it comes to selecting clients. You want to photograph weddings—but before you promise a bride the world, you need to make sure she knows what is expected of her. There's more to it than just making sure you get paid. You need to present a set

of policies that you won't bend just to get the wedding. These non-negotiable policies define your conditions for taking the job. Or, put another way, unless the bride agrees to these points, you won't agree to be her photographer.

For the next few pages, I want to go over those policies which I believe are important enough to be included on the front side of the wedding contract we use here at my studio.

Only "Official" Photographer

> *We agree Steve Herzog Photography is authorized as the only professional photographer at the wedding, and that guests may take photographs only as long as they do not interfere with the photographer's duties.*

Most brides aren't in the market to hire a *second* professional. No, the issue addressed with this policy is the guests—and let's face it, they can be a problem. Armed with their amateur skills and professional cameras, they get in the way, are a distraction for the people you're trying to photograph, and generally make it hard for you to do your job. I know you know what I'm talking about.

There's more at stake here, however, than just your comfort level. You're in this business to sell photography. If you've spent ten years learning how to set up and create beautiful wedding pictures, the last thing you need is for someone to stand back patiently while you get everything ready, wait until every detail is just right, then raise their camera and in 1/125th of a second produce a virtual copy of your photograph—and likely rob you of that sale*. You're not in this business to set up pictures for amateurs.

Still, you don't own the wedding. Weddings aren't staged for your monetary benefit—which means you must find a reasonable middle ground which ensures that you'll get your pictures *and* sales—and the friends and relatives will have their chance to burn a little film.

My general policy is this: I don't want snapshooters swarming around when I'm taking *posed* pictures, which I've set up, at the house, ceremony, or reception. Those pictures are my creation, and I want my camera to be the only one at the wedding carrying those shots. If the guests want to set up and take other pictures on their own, then the bride and groom are fair game.

When I'm going over this policy with a bride, I hit on two main points:

• First, that "We have only a limited amount of time at the wedding to take all the pictures you want." She needs to understand that her wedding day

* Don't lull yourself into a false sense of security by thinking that because your photography is *professional*, people will always choose it over Uncle John's free snapshots. Not true. For many people, a professionally posed snapshot is wonderful…and far better than they could have done if you hadn't so kindly set it up for them.

will be a hectic and fast-paced few hours, and neither of us will likely have the time (or patience) to accommodate the hordes of guests tripping all over themselves to get their pictures. I explain that the more time we spend on crowd control, the less time we'll have to devote to creating beautiful photography.

• Second, that if I am forced to battle guests, "I can't *promise* that the quality of my photography will be up to your expectations." In other words, I'll do my best, but that might not be very good—and I make a point of stressing that if it's going to be a hassle, I'd just as soon not be the photographer. After all, "I have a professional reputation to protect."

Depending on how quickly the bride understands my viewpoint, you'd be amazed at how many horror stories I can come up with about once-in-a-lifetime pictures lost, *down the toilet!*, because of unruly, camera-toting guests. Most brides have been to enough of their friends' weddings that they know right away what a mess this can become. By the time I'm done, most brides are 100% on my side, and will come to my rescue at the wedding if they see their guests are interfering with my artistic duties—or their pictures.

On several occasions, after talking the "guest problem" over with brides, I've declined their invitations to become their photographer—and simply told the bride that I believed they'd be happier with someone "more accommodating". I didn't like turning down an otherwise good assignment, yet at the same time I knew that if I was patient, the phone would probably ring again with another bride planning a wedding for the same date. Most of the time, my patience paid off, and I ended up going to weddings which were just as nice...and where I didn't have to fight the guests. It was worth it.

No matter what specific policy you adopt regarding guests' picture taking, it's important that those policies are presented to the bride in a way which maximizes her concerns and minimizes yours. This requires a little finesse. You want her to make the conscious decision to assist you in making sure you have every uninterrupted opportunity to produce the kind of photographs she's been dreaming about. You'll know you've succeeded if, at those weddings, you hear a bride gently lecturing guests, "It would be best if you waited until later to take your snapshots. Right now, we're taking the *professional* pictures."*

The bride is just about the only person at a wedding who can get away with lecturing guests, and have the guests listen—and obey. If *you* tried talking that way to guests, you'd have a riot on your hands, and there's no way you'd win, if you trap the bride in the middle of a fight between you and the guests. You're much better off if you've got the bride protecting you.

* It's not nearly as difficult as you might expect to enlist the bride's help. Many brides would just as soon not have their guests running amok with their cameras—but don't have a good way of getting out of a ticklish family situation. One way to look at is that you're supplying the excuse the bride needs to ask guests to show some restraint.

Negative and Proof Ownership

We understand all negatives and Preview prints are owned by Steve Herzog Photography, and are not included as part of the reserved Coverage. (Refer to the separate Wedding Services Price List.)

That I own the negatives and proofs is a point I've learned to stress every chance I get. Unlike years ago, I can no longer tell brides, "photographers *always* keep their negatives." I know it's not universally true...and so do brides. In my area, starting a few years ago, several pros now advertise the fact that "negatives are included" from all their assignments. Including weddings. With this policy, I am making it perfectly clear that I am not one of these photographers.

To make my point, at the time of the booking and contract signing, I briefly explain to the bride and groom that the coverages listed on the price list include only finished prints and albums. The negatives are not for sale. If I'm asked whether they can buy (or have) the negatives, I simply say, "We keep the negatives on file. I have all the negatives from all the weddings I've ever photographed, so you can reorder prints at any time."

The proofs are another matter entirely. If the bride and groom wish to *purchase* the Previews, they can, *as a set*, for an additional charge. With this policy, I am basically covering myself (again) should the question ever arise over who owns those proofs. I do, at least until they are bought and paid for.

Of course, if you are a photographer who *does* include negatives and/or proofs within the basic price of your coverages, then you'll want to modify this policy to fit the way you work. *But, may I make a suggestion?* Instead of simply stating that "negatives/proofs are included", why don't you tie their sale to your largest coverages *only*. Or, sell the negatives on a sliding scale: higher prices when the orders are low, and lower prices when they're large. If the orders are very large, then yes, you can toss in the negatives as a way of saying "Thanks!" Proofs and negatives are just too powerful as sales tools to just throw in gratis, for free. At least make people *work* for anything you're giving away!

Deposits Follow Schedule

We agree to the deposit schedule listed below. We understand our deposit applies only to the above date. We also understand the deposit is non-refundable.

All brides need to understand at what point(s) the money is due. These important details shouldn't be hidden on the price list; they should be right out in front, on the contract, where brides can see them, sign for them—and where you can quickly point to them should the bride forget.

The first sentence of this policy is a reference to the Schedule for Deposits & Payments at the bottom of the contract. I mention it here as a way of steering

the conversation in the direction of money, and to make sure the bride understands that her paying me on time is just as important as my being to the church on time.

Then there's the matter of what to do when a wedding is canceled or the date changed, and you're not available on the new date to do the photography.

Right on the contract, you should state that the deposit used to reserve the date applies only to the date listed. In other words, the bride can't tell you in November that she's getting married in May, then in March tell you the date's been changed to September, and still expect you to be automatically available. It won't always happen that way. If you are available for the new date, then you should change your schedule. *And what if you're already booked for that date?* You reserved the original date in good faith, and have possibly turned away other weddings since then, because you *thought* you were booked. If it's in your contract that the deposit applies only to the original date, then you're covered if the wedding date changes and you can't do the photography. You don't have to return the deposit.

I don't have to tell you that this situation of refunding deposits can become messy very quickly. That's why you absolutely must have a clearly stated policy written into your contract. The safest wording I've found is to clearly state that "the deposit is non-refundable." It's short and to the point. While in reality there may be situations when you'd refund the deposit, stating on the contract that the deposit is not refundable is your best bet for remaining in control of the situation. (This policy is an important one. It will be discussed in more detail in the next chapter.)

Pricing Depends On Following Schedule

> *We understand the prices quoted apply only if deposits are paid on time, and orders placed as later agreed upon. If not, the prices used for our order will be those in effect at the time of our wedding.*

Here's the situation which led up to this policy: The bride paid all deposits on time, and I took the photographs. She picked up proofs, and we agreed on a date they would be returned, with the orders. So far, so good. Then, the date she agreed to return the proofs comes and goes. I politely called to remind her; she curtly informed me, "My parents have the Previews, and they live out of state. Since we've paid for our album in full, I'll return the Previews when my folks send them back. I'll call you." End of conversation.

What griped me about this was that I had no recourse. At the time, my pricing was open-ended. I promised to produce an album full of a set number of prints at a set price. The prices for parents' albums, and other loose prints were also locked in. The assumption has always been that brides would quickly return their proofs and place their orders. It hadn't occurred to me that I might have to

wait months (or, conceivably, *years*) before I would have the orders and be able to have the prints made at the lab.

I didn't like this situation. I didn't like committing to a set price, and then being put in the position of having to swallow any price increases from the lab, album company, or from any other "costs of doing business." I wanted the order to remain on track and keep moving to completion.

It wasn't long after this wedding that I added this policy to my contract. I wanted an "if" clause: I will agree to lock in prices *if* the bride follows through and places her orders on time. *If* she doesn't, then she runs the risk of paying higher prices.

With this policy in place, I had some leverage. Now, in those rare situations where an assignment stalls and seems to be going nowhere, I can let the bride know that she could lose her lock on "old" prices if she doesn't quickly make arrangements to return the proofs and all the orders.

It's amazing what an effective motivator it can be to tell a bride that "The price list we're using now is 15% higher than the one we had when you booked your wedding. If you want to hold those old prices, you really do need to be getting your order back *very* soon." Works every time.

I should add that the wording, "the price list used for your order will be that in effect at the time of your wedding" refers specifically to the way I book weddings. My price lists are based upon the date the wedding is booked, not the wedding date itself.

For example, let's say we're talking about a wedding date in November. If one couple calls in January, the prices they'll hear will be those being quoted in January; a couple calling in August will see a price list with August's prices. The wedding date has nothing do with it. Regarding this policy, if a couple was scheduled to bring back proofs, and place their order, in June, and didn't make it in until August, then they, too, would now be using August's prices. If they had returned their order as agreed upon—or at least called to make other arrangements—then their prices would have held as originally booked.

Photography is Copyrighted!

> *We understand all photographs from Steve Herzog Photography are copyrighted, and may not be copied in any manner. We agree all prints from these photographs will be ordered only from Steve Herzog Photography.*

Copying photographs is absolutely rampant nowadays. One hour labs, color copiers, computers, video—all of these new technologies are conspiring to rob professional photographers, wedding and otherwise, of the income we deserve from our efforts. There's nothing you can do to stop the *technology*—but there are ways you can put the law on your side to make it less easy (and more painful) for anyone to copy your photography, and undermine your income.

You've got to protect yourself!*

On my contract, I am no longer shy about discussing the issue of copying, and copyrights. When the bride and I reach this part of the contract, I show her the back of one of my sample prints, with its copyright stamp, and go on to politely explain why *all* my photography carries the message "Copyright 19XX, Steve Herzog Photography. Unlawful to copy". Some brides are surprised. Some have that look on their face which tells me they know all about copying. Once or twice, brides have let me know that they wouldn't hire me if I insisted on adding the copyright notice to the back of their prints. I tell them fine, and steer them to one of my beloved competitors.

Call me naive, but I believe most people are honest. (Yet not *all*. I didn't say I was stupid!) While some people will copy anything they can no matter what the law says, and while there are plenty of companies who will help them do it, for most people it's a matter of simply not knowing it's illegal. After all, they bought and paid for those prints—and it's their wedding—so why not?

Fact is, while I can't stop everyone from copying, I figure that if I can cut crime by 40%, I'm ahead. I do what I can. At the very least, I know I made it harder for them to steal from me. I've also done my bit to educate the brides of America on the fine points of copyright law. It helps me sleep better at night.

Limiting Liability

> *We understand Steve Herzog Photography will do everything possible to ensure the successful completion of this assignment. We agree liability is limited solely to the refund of deposits.*

When it comes right down to it, this paragraph is 51% of the reason for having a contract at all. It's *that* important!

Let me put it this way: if a sweet little bride hires you to photograph the most important day in her life, and you screw up, there's not a judge or jury that wouldn't take pity on her...and hang you by your camera strap.

The foul up which destroyed her wedding pictures doesn't even have to be your fault. Maybe your lab had a processing glitch, or the delivery truck ran over your box of otherwise perfect negatives, proofs and/or prints. Maybe the dog ate them. *It doesn't matter.* As far as the bride is concerned, you promised her pictures—and you didn't deliver. You're the one she'll come after first.

* If you doubt how much copying is going on, talk with people at a local one hour lab. They'll tell you that an *enormous* amount of obviously professional work is brought in by customers looking to save the "expense" of having to pay the pro who took those pictures to have additional prints made. I guarantee that after this conversation, you'll be as militant as I am about doing everything possible to protect yourself from those clients who are so happy with your photography that they want more copies—but just don't want to pay *you* for them.

If you plan to survive and prosper in this business, you've got to protect yourself from the unthinkable. With this policy in your contract, and the bride's signature on the dotted line, you and the bride have agreed there are limits to your liability. By signing the contract, she acknowledges your promise to do everything humanly possible to deliver her wedding pictures intact and in good condition. BUT, should something go wrong, she also agrees that she won't level the legal system at you and shoot your business dead. She'll get her deposits back, along with your *very* sincere apologies.

When discussing this part of my contract with brides, I've found it helpful to be up front about the fact that this is an imperfect world. Bad things can happen to good photographers...and their clients. With this section in my contract, I have the chance to address the remote possibility that things won't go as planned—and stress that I go to great lengths to make sure everything will go well with their assignment. I promise to do my best. I do, however, stop short of promising her immunity from Acts of God.

So, while the previous policy about copying may help me sleep *better*, this policy lets me get any sleep at all. I wouldn't go to a wedding without this sentence in my contract!*

Delivery Upon Full Payment Only

> *We understand no finished prints or albums will be delivered until the full balance for all photographs ordered from our wedding has been paid, and that there can be no partial deliveries.*

Over the years, I've learned that it's worth the time and space to let a bride know that even though different people may purchase prints from her wedding, *from my standpoint* all those pictures make up a *single* order.

Here's a very typical example of how problems can arise *without* having a "one wedding/one order" policy:

Barbara hired you to take pictures at her wedding. By the time she picked up her proofs, she had paid for her album in full. When she placed her order, she wrote down her orders in the proof books. The parents, relatives and assorted friends marked down their own orders. Now, all those finished prints are ready for delivery. When the bride arrives to collect her photographs, she calmly says, "I didn't bring the money for the other peoples' pictures. I had trouble collecting from them. Since I've already paid for our pictures, I'm going

* In addition to your signed contract, it's wise to have additional protection...just in case it's you who messes up. Here's where belonging to the Professional Photographers of America can help. The PPA provides the only insurance program I'm aware of that offers liability insurance for wedding photographers. Getting this coverage is reason alone for joining the organization. To find out the current specifics, call the PPA at 404-522-8600. Their address is 57 Forsyth St. NW, Suite 1600, Atlanta, GA 30303.

to pick up just our album. The other people, I'm sure, will be over soon to pick up the pictures they ordered."

Yeah, right. And every bride is ready on time, too.

And, in a way, Barbara is within her rights. Unless you agreed to something different when the wedding was booked, you likely agreed to supply a finished album in exchange for a certain number of dollars. Barbara is all paid up, and now she wants her pictures. What about all those extra prints? Well, as far as Barbara is concerned, that's between you and those "other people".

As it stands, with Barbara's wedding, it might well be months, maybe years (maybe never) before you deliver the prints to all those other folks. It's going to be tough. If all they did when ordering was write down a first name in the proof book, you probably don't even know who they are, their addresses, or their phone numbers. It's going to take a lot of time, and a lot of work, to ever deliver those prints. Otherwise, you're left holding those bags of expensive prints.

To avoid this situation, you need to use the wording in your contract to set in place the policy that you view all photographs from a single wedding as a single order. With this approach, the Bridal Album is part of the larger order, not separate from it. And, the money the bride has paid is a *deposit* towards the total due for all those pictures.

It's really quite simple—as long as you set it up correctly.

I'd like to add that it's been my experience that most brides think this policy is fair and reasonable. Each bride knows, because I've told her, that while we're having the prints made, she should be collecting all the money for all the orders. This way, when the call goes out that the pictures are ready, she knows to bring payment for everything. When she leaves my studio, she leaves carrying all the photographs. It makes for a neat and clean sale—just the way it should be.

Agree to Abide By Policies Statement

> *We further agree to abide by the Financial Arrangements & General Procedures listed on the reverse side of this Contract for Wedding Photography.*

As I mentioned earlier, the front side of the Wedding Contract covers what I call the hard, "non-negotiable" policies I have adopted for weddings. As important as they are, these aren't the only policies that will help keep the assignment moving along smoothly. There are more—and these *additional* policies are listed on the reverse side of the contract page.

The official name I use for these flip side policies is "Financial Arrangements & General Procedures". Unofficially, these are the Policies Statement I've been referring to.

I make this reference to those policies on the front of the contract just to make sure the bride knows where to find them. And, most importantly, I want her to realize that these policies are an important part of the overall contract.

Because the Policies Statement is so important, it will be discussed, in its entirety, in the next chapter. Stay tuned.

Schedule for Deposits & Payments

Once you've gone through all the main points of your contract, most brides will want to know about money and deposits—and what it takes to reserve your services for their wedding date.

Here's my system: to reserve the date, the bride pays one-half the price of the coverage selected upon signing the contract, then the balance a month before the wedding. (Later, at the wedding, if I'm asked to stay any additional time, the money covering those hours is due when the proofs are delivered.)

At the bottom of my contract, these policies are summarized. When the bride hands me her deposit check, the amount paid is written down on the contract. I make a point of letting her know that we'll need to schedule a meeting a month before the wedding to discuss details of the wedding, and pay that second deposit.

This approach is pretty straightforward. My objective is simply to have all the Bridal Album money collected before the proofs are released. And that's just what happens. There's no reason to have money-related policies which are anything but airtight and bulletproof.

Signatures and Date

After you and the bride have discussed the points listed on the front side of the contract, and you've answered her questions, it's time (finally) to ink the deal.

From the moment you and the bride sign, you're both committed. You're now her photographer. You've outlined for her what you're going to provide in the way of photography and time, in exchange for a specific amount of money.

Now begins the often long, but hopefully smooth, process of taking the pictures, collecting the order and payments, and eventually delivering the finished prints. If your policies make sense, and if you've done a good job of explaining them, you should have smooth sailing.

2

The Policies Statement: Controlling The Details

If you think a bride has questions *before* her wedding, wait until you see what's coming once you've been hired. No longer are you trying to convince her that you're the best photographer they've ever seen. You've done that, and she's putting her money where your mouth is—and she's going to have plenty of questions about how you're going to earn each one of those dollars.

If you want your new relationship to go smoothly, you'd better have your answers polished and ready.

If you can't answer her questions, you can be sure that the wedding will quickly become a mess. Multiply that mess by a year's worth of weddings, and you can see that you're setting yourself up for an ongoing catastrophe.

What Happens Now. What Happens Next.

The good news is that good answers make good business. Hopefully, if you've noticed that happy brides place larger orders than brides who are upset with their photographers. If so, then you'll want to do everything you can to make

sure your brides—*all of them*—are in a cheerful buying mood when it's time to make their selections. And write those checks.

The Policies Statement, Line By Line

The best way to handle those inevitable question-and-answer sessions with brides is to automate the process. Most of the business- and policy-related questions you'll hear from your next bride are the same basic questions you've heard from the many brides who've come before: "How long can we keep the proofs?", "When is the rest of the money due?", "How long does it take to get the pictures?" (You've heard those, right?) This fact alone makes it easy to anticipate, and answer, most of what brides want to know as they go about the task of planning the perfect wedding.

Don't waste your breath trying to answer brides' questions verbally. Brides have a lot on their minds—which means that your chances are slim to none that the majority of your brides will remember what you *said*. Or, just as importantly, remember it *correctly*.

Give yourself a break. Instead of answering each question individually, organize your policies on paper in such a way that you can a) hand the bride a copy when she first books with you, and b) have something to refer to when she asks the Standard Question(s) anyway. Having this information written down will save you and the bride loads of time and trouble.

Equally important, the fact that the bride received a copy of these answers (i.e., policies) means that you no longer have to worry that she either won't remember what you said, or remembers it incorrectly. You've got proof that what you told her then is the same thing you're telling her now.

In my business, the answers are listed on the all-important Financial Arrangements & General Procedures page. Or, informally, the Policies Statement. This form is printed on the back side of the Wedding Contract. In it, step by step, are outlined all the stages a wedding assignment goes through from the time the wedding is booked until all orders are paid for and picked up.

Over the next few pages, we'll go over the Policies Statement. I'll outline what it covers, why it's worded the way it is, and what I'm trying to accomplish by structuring it the way we do. Then, I'll let you take it from there, in adapting it to your community, your weddings, and your own way of working.

Starting at the beginning, when the wedding date is first reserved, here is the sequence of steps all my weddings go through until the finished prints are delivered and the assignment is complete.

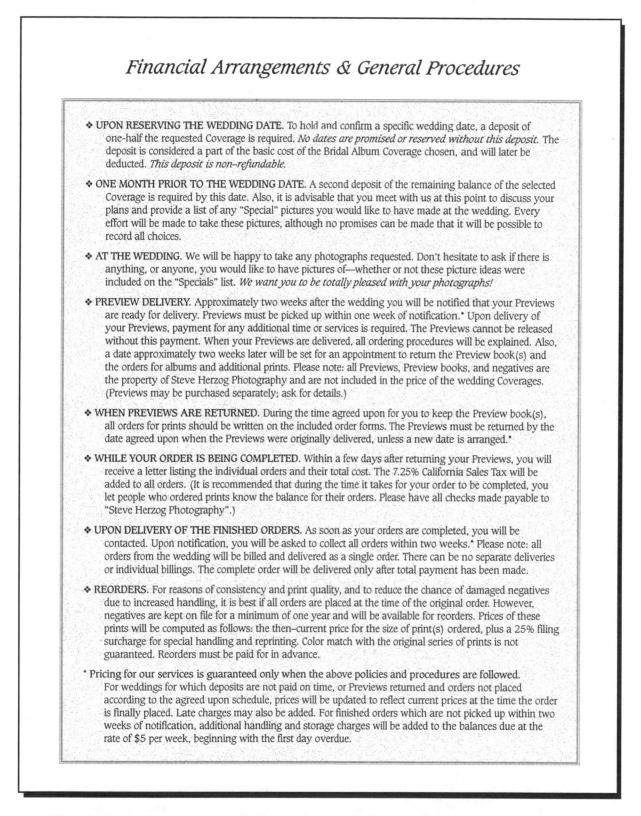

Financial Arrangements & General Procedures

❖ **UPON RESERVING THE WEDDING DATE.** To hold and confirm a specific wedding date, a deposit of one-half the requested Coverage is required. *No dates are promised or reserved without this deposit.* The deposit is considered a part of the basic cost of the Bridal Album Coverage chosen, and will later be deducted. *This deposit is non-refundable.*

❖ **ONE MONTH PRIOR TO THE WEDDING DATE.** A second deposit of the remaining balance of the selected Coverage is required by this date. Also, it is advisable that you meet with us at this point to discuss your plans and provide a list of any "Special" pictures you would like to have made at the wedding. Every effort will be made to take these pictures, although no promises can be made that it will be possible to record all choices.

❖ **AT THE WEDDING.** We will be happy to take any photographs requested. Don't hesitate to ask if there is anything, or anyone, you would like to have pictures of—whether or not these picture ideas were included on the "Specials" list. *We want you to be totally pleased with your photographs!*

❖ **PREVIEW DELIVERY.** Approximately two weeks after the wedding you will be notified that your Previews are ready for delivery. Previews must be picked up within one week of notification.* Upon delivery of your Previews, payment for any additional time or services is required. The Previews cannot be released without this payment. When your Previews are delivered, all ordering procedures will be explained. Also, a date approximately two weeks later will be set for an appointment to return the Preview book(s) and the orders for albums and additional prints. Please note: all Previews, Preview books, and negatives are the property of Steve Herzog Photography and are not included in the price of the wedding Coverages. (Previews may be purchased separately; ask for details.)

❖ **WHEN PREVIEWS ARE RETURNED.** During the time agreed upon for you to keep the Preview book(s), all orders for prints should be written on the included order forms. The Previews must be returned by the date agreed upon when the Previews were originally delivered, unless a new date is arranged.*

❖ **WHILE YOUR ORDER IS BEING COMPLETED.** Within a few days after returning your Previews, you will receive a letter listing the individual orders and their total cost. The 7.25% California Sales Tax will be added to all orders. (It is recommended that during the time it takes for your order to be completed, you let people who ordered prints know the balance for their orders. Please have all checks made payable to "Steve Herzog Photography".)

❖ **UPON DELIVERY OF THE FINISHED ORDERS.** As soon as your orders are completed, you will be contacted. Upon notification, you will be asked to collect all orders within two weeks.* Please note: all orders from the wedding will be billed and delivered as a single order. There can be no separate deliveries or individual billings. The complete order will be delivered only after total payment has been made.

❖ **REORDERS.** For reasons of consistency and print quality, and to reduce the chance of damaged negatives due to increased handling, it is best if all orders are placed at the time of the original order. However, negatives are kept on file for a minimum of one year and will be available for reorders. Prices of these prints will be computed as follows: the then–current price for the size of print(s) ordered, plus a 25% filing surcharge for special handling and reprinting. Color match with the original series of prints is not guaranteed. Reorders must be paid for in advance.

* Pricing for our services is guaranteed only when the above policies and procedures are followed. For weddings for which deposits are not paid on time, or Previews returned and orders not placed according to the agreed upon schedule, prices will be updated to reflect current prices at the time the order is finally placed. Late charges may also be added. For finished orders which are not picked up within two weeks of notification, additional handling and storage charges will be added to the balances due at the rate of $5 per week, beginning with the first day overdue.

The *Policies Statement's* role is clarifying and restating the Contract's main points in a more conversational manner. It uses a timeline format, so the bride will know which policies apply as the assignment progresses. These Policies are printed on the back of the Wedding Contract.

Upon Reserving The Wedding Date

> *To hold and confirm a specific wedding date, a deposit of one-half the requested Coverage is required. No dates are promised or reserved without this deposit. The deposit is considered a part of the basic cost of the Bridal Album Coverage chosen, and will later be deducted. This deposit is non–refundable.*

Money talks. The only way that you can be positive that a couple wants you, and only you, as their photographer is to watch as they hand you a check as the deposit for your services. *Now that's commitment!* Anything less than negotiable currency has the potential to come back as empty promises.

• *To hold and confirm a specific wedding date, a deposit of one-half the requested Coverage is required. No dates are promised or reserved without this deposit.*

Perhaps the biggest mistake you can make when talking with couples who have not yet booked is to tell them you'll "hold the date" for them, even though no deposit has yet been paid. It's an open invitation for them to continue shopping around. And why not? They've paid nothing, yet have a photographer (you) on hold, waiting patiently, until they finally make up their minds. *Why rush?* With you in reserve, if they can find a better deal in the meantime, it's no loss to them. But, for you?...well, that's another story. If you've been turning away other weddings thinking you were (almost) booked, then you could easily end up losing thousands of dollars.

Early in my career, I had a wedding that left me watching helplessly as this exact scenario played out. I'd told a bride I would hold the date for her, and didn't find out until the week of the wedding that she and the groom had changed their minds and hired another photographer. (I wondered why I hadn't heard from her.) Because she had paid no money, they felt no reason to call. When I called them, the bride said, "Oh, we never *really* hired you. When we talked with you, we were still looking. Sorry for the inconvenience—but we won't be needing you." As they say, live and learn. I sat home that Saturday.

With 20/20 hindsight, when the bride asked me to hold the date for her, this is what I should have told her: "I get a lot of calls from brides asking me to be their photographer. I'd like to hold the date, but the only way I can do that is with a deposit. That's the only way I have of knowing, for sure, who wants to work with me—and who is still shopping around. Since I can't hold the date for you without the deposit, you should make a decision and get back to me as quickly as you can. It sounds like you're planning a great wedding, so I do hope you call back before someone else books 'your' date."

And that's basically what I'm saying here in the Policies Statement.

What I like most about this "no deposit/no promises" policy is that it shifts the decision making back where it belongs: onto the bride and groom. I don't want to have to keep track of which dates are "on hold". When I've met with a couple and they leave without booking, and the phone rings a few minutes later

with another bride asking about the same date, I want to feel totally comfortable telling the second bride, "Yes, we've gotten several calls about that date—but as of right now, it's still available. When can you come over to the studio to look at samples?" It's purely a situation of first come, first served.

There's nothing wrong with fostering the impression that you are one busy wedding photographer—and that brides are fighting over you. In fact, that perception, and this policy, will help convince couples to move quickly to get their deposit money into your checking account—and lock you in as their wedding photographer. There's no sense in dragging the process out.

> • *The deposit is considered a part of the basic cost of the Bridal Album Coverage chosen, and will later be deducted.*

You need to state precisely how the deposit will be applied and credited. When the bride hands you that check, will that money be applied to her Bridal Album only, or is that money going to be applied to all orders—including those from parents, relatives, and friends? It's an important distinction.

As we discussed earlier, the policy I recommend is that you make all photography part of a single order. From your standpoint, it doesn't matter whether the prints are going into the Bridal Album, Parent Album, or wherever. There's no way, if you're a busy photographer, that you can keep track of individual orders from each of your weddings.

This is a good example of where it pays to clearly define your policy, then make sure you've got it down in writing. Since this "one wedding/one order" idea is such an important policy, it's written down both on the front of the contract and in the Policies Statement. I don't want there to be any room for misunderstandings. I want that "something to point to".

> • *This deposit is non–refundable.*

Without reservation, I can say that the issue of refunding deposits has been one of the messiest, most irritating, most exasperating quagmires I've ever seen. That's why I highlight the point that *deposits are non-refundable* no less than three times in the contract and Policies Statement.

Over the last 20 years, my policies have gone through several well-intentioned, but flawed, phases. At first, I was Mr. Nice Guy. You say you canceled the wedding? Changed the date to one for which I was unavailable? (Found another photographer?) *No problem!* Deposits are refunded, in full, no questions asked. I abandoned this approach once I saw how it played havoc with my schedule, and left me holding the bag when a wedding fell apart. I didn't like feeling like a schmuck.

Next, I tried compromise. My new, improved, reformulated policy: I'd refund the deposit only if the wedding was more than six months away, or if the wedding date was later booked by another couple. This policy didn't last long either.

In fact, I gave it up after a bride screamed into the phone, "How do I know you're going to tell me if someone else books my date? I think you're just trying to keep my money!" That did it. I immediately fired up my computer, opened the Wedding Contract and Policies Statement, and furiously deleted all references to any sort of refunds in my contract. From that day on, all deposits have officially been "non-refundable."

This final approach has worked the best of any I've tried. It's black and white. Plus, once again, it places responsibility back onto the couple to know, *for sure*, whether they are really going to get married, or if their wedding date will hold. Now, when a couple pays their deposit and reserves a date, it's understood that they are accepting responsibility for the stability of *their* plans.

Having a clearly worded policy, on paper, also helps when the bride calls a month before the supposed wedding date to say she and her beau have decided to elope and need their deposit back to pay for bus fare to Las Vegas. Well, I'm sorry, but as the contract says, the "deposit is non-refundable." I can't word it any more clearly than that.

That's not to say that I never refund deposits. I do, *but only if, and when, I decide to do it.* If the bride and groom have what I consider to be a good reason for wanting their deposit back, then, at my discretion, I can elect to refund it. If not, I don't. It's that simple. Best of all, because this policy was spelled out on the contract when the date was originally booked, I don't have to defend myself. I'm sorry, but that's just the way it is.

If you're still not sure of this policy and whether you should adopt it, look at it this way. Brides are coming to you. You're committing your schedule to meet their needs. You're doing everything you can to accommodate them.

If one bride reserves your services for a particular Saturday, that means you've promised to turn away any other brides who call for that date. If the bride's plans change, it's patently unreasonable for her to expect you to simply return her deposit as if nothing happened. A lot did happen! You turned away other weddings! Your business has lost income not because of anything you did, but because the bride didn't have a lock on her plans. In other words, it's not your problem—and you shouldn't have to pay the price.

One Month Prior To The Wedding Date

> *A second deposit of the remaining balance of the selected Coverage is required by this date. Also, it is advisable that you meet with us at this point to discuss your plans and provide a list of any "Special" pictures you would like to have made at the wedding. Every effort will be made to take these pictures, although no promises can be made that it will be possible to record all choices.*

By this point, the wedding has been on the books awhile and you are within a few weeks of photographing the event. You need to do two things: col-

lect any money due, and double check with the bride to make sure nothing major has changed since you last met.

> • *A second deposit of the remaining balance of the selected Coverage is required by this date.*

Having any remaining balance paid before the wedding is fairly typical within the industry, and it makes good sense. This policy guarantees you get paid, *in full*. It also provides the up-front money you'll need for film, proofing, and other costs. You definitely don't want to be taking money out of *your* pocket to pay for the pictures! Chances are, the bride has been exercising her checkbook quite a bit by this point, so you might as well make sure some of that money is moving in your direction.

It's risky to postpone payment until *after* the wedding. I know. For years, I had the policy that had people paying one-half the *remaining* balance, rather than the entire balance, a month before the wedding. The final balance was then collected when the Previews were delivered. This approach caused it's share of problems—most often because the bride and groom had spent my money on their honeymoon. This lack of funds on their part caused a delay in picking up the proofs, which, in turn, caused the final orders to be smaller. I finally adopted the policy of collecting the balance for the booked package before the wedding. It's been smooth sailing ever since.

> • *Also, it is advisable that you meet with us at this point to discuss your plans and provide a list of any "Special" pictures you would like to have made at the wedding. Every effort will be made to take these pictures, although no promises can be made that it will be possible to record all choices.*

One task I assign to brides is what we call the "Special's List." As I tell brides when they first book, "You don't have to tell me to take photographs of you and the groom, or of the cake. I know you want those pictures. I've been taking notes as we've discussed your plans. But, where I need your help, is with the *special* pictures I might not know to take, unless you tell me about them. Pictures of special people, family traditions, anything. If you don't tell me about these pictures, I might miss them."

Do all brides come through with their list? Nope. I'll be the first to admit that many don't get past jotting down a few basic ideas. *But that's OK.* The point is that I'm letting brides know that how well their pictures turn out depends not just on me—but on them, too. It's a team effort. I make it clear that if I don't get the list, then the best I can do is guess. With the list, my chances of getting the pictures they want are much improved. *But it's up to them to supply the list.*

With the last sentence of this policy, I stress that while I'll do all I can to get the pictures listed, I can't promise (i.e., guarantee) to take each and every one. Real weddings are not always as organized as brides imagine. And, the number of hours I'm hired for doesn't always allow the time I'd need to get all the pictures the average bride can dream up...at least not without paying for *additional* time. If she wants me to stay longer, we can discuss *that* at the wedding.

At The Wedding

> *We will be happy to take any photographs requested. Don't hesitate to ask if there is anything, or anyone, you would like to have pictures of—whether or not these picture ideas were included on the "Specials" list. We want you to be totally pleased with your photographs!*

Ah, the wedding day! Getting the emotions and event down on film is what it's all about.

With this paragraph, what I want to do is redirect the bride's attention to the fact that on the wedding day I prefer *not* to be "distracted" by business considerations. I want the bride to know that at her wedding I am at her service. I make it clear that I'll take any pictures they want. I want them to know I'm working for them.

Making sure that this ideal becomes the reality is, again, the job of all the policies we've been discussing. I know that if I've followed through on the policies listed in the contract and Policies Statement, by the time the wedding day arrives, I will have been paid in full, have a list of pictures the bride and groom want, and know precisely (more or less) what to expect during the hours we're working together.

All that's left is to take the pictures. On the wedding day, those photographs are all I want to be thinking about. They set the stage for what happens next: sales.

Preview Delivery

> *Approximately two weeks after the wedding you will be notified that your Previews are ready for delivery. Previews must be picked up within one week of notification.* Upon delivery of your Previews, payment for any additional time or services is required. The Previews cannot be released without this payment. When your Previews are delivered, all ordering procedures will be explained. Also, a date approximately two weeks later will be set for an appointment to return the Preview book(s) and the orders for albums and additional prints. Please note: all Previews, Preview books, and negatives are the property of Steve Herzog Photography and are not included in the price of the wedding Coverages. (Previews may be purchased separately; ask for details.)*

Once the proofs are back from the lab, it's time to begin turning those Previews into orders, and then into prints. It's a time-consuming, multi-step process. To make sure the bride understands what those steps are, I've found no substitute for spelling them out word by word.

• Approximately two weeks after the wedding you will be notified that your Previews are ready for delivery.

All brides ask the question, "How long before we get to see our pictures?" Rather than quoting unrealistically short delivery times, and risk having to explain why the Previews are late, your best bet is to give yourself some breathing room. Do that by changing the point when those proofs are *officially* overdue. Two weeks should be plenty of time. It's much better to quote a longer time than you'll reasonably need, then surprise the bride with an earlier-than-expected phone call saying, "Your Previews are ready!" You'll be a hero.

*• Previews must be picked up within one week of notification.**

Coercing couples into collecting their Previews is not usually a problem. Still, on my contract, I want to have it in writing that couples need to pick up their proofs quickly. I know they're anxious to see the pictures, and I know I want to see the ordering process get started.

For the most part, this idea is really a carryover from my earlier policy of still having large sums of money to collect after the wedding. Back then, I needed to insist on quick pick-ups because there were many times when I was left sitting on proofs for weeks and months while the happily married couple scrounged around for cash.

Even after I changed my deposits policy, I saw no reason to delete this sentence from the Policies Statement. I didn't want to take any chances on reliving bad experiences, and not having something in writing to back me up.

(The asterisk (*) at the end of the sentence refers to the last paragraph of the Policies Statement, which outlines for the bride what the penalties are when agreed-upon policies aren't followed. We'll discuss this later.)

• Upon delivery of your Previews, payment for any additional time or services is required. The Previews cannot be released without this payment.

These two sentences restate the obvious: If any money is owed after the wedding, it must be paid in full before the Previews will be released.

Because my packages are based on time, it's quite common to have a bride book, for example, a five hour package, then at the wedding ask me stay an extra hour or two. How I charge for these extra hours is listed on my price list, but via the Policies Statement I want it understood that these extra charges are due when the Previews are delivered.

To notify the bride and groom of the exact amount of money due, I don't hand them an invoice as I leave the reception. Instead, immediately after the wedding I send a letter listing any additional charges and, once again, let them know to bring this money with them when they come to collect the Previews.

• *When your Previews are delivered, all ordering procedures will be explained. Also, a date approximately two weeks later will be set for an appointment to return the Preview book(s) and the orders for albums and additional prints.*

If you do a lot of weddings, you know how much time it takes to keep assignments on track and moving forward. Getting proofs returned, and final orders placed, is a good example of a situation where a wedding can quickly bog down. By listing an approximate time on the Policies Statement that the bride and groom can keep the Previews, they have something to refer to when deciding how long family and friends can keep the proofs to look at while deciding what to order.

While, on the Policies Statement, I list two weeks as the approximate length of time the Previews will be checked out, in reality I let each individual wedding guide me in setting the actual return date. If all the family lives close by, and the proofs won't be leaving town, then I'm agreeable to a two or three week check out period. On the other hand, if parents and others who would likely want to order prints live out of town, then the bride and groom have no trouble talking me into maybe four weeks. The time allowed isn't as important as the understanding that a firm date has been set for the proofs' return. I *hate* open-ended policies!

It's rare, however, for me to agree the proofs can be checked out for longer than a month. Why? Because the orders will go cold. I don't like the idea of producing a nice set of photographs, giving people ample time to enjoy the images, and then having them return those proofs and tell me they don't need to *buy* any because they've looked at them enough.

• *Please note: all Previews, Preview books, and negatives are the property of Steve Herzog Photography and are not included in the price of the wedding Coverages. (Previews may be purchased separately; ask for details.)*

Repetition never hurts! Since this is the part of the Policies Statement the bride will be reading (hopefully) when she has questions about proofs, I opted to recycle this policy from the front of the contract. As I mentioned earlier, I don't want to take the chance that anyone, anywhere, will assume that the negatives and/or proofs are included in the price of the Bridal Album package. That's not the way I work.

With regard to the sale of proofs, you'll notice that while I say that Previews are not included in the price people are paying for the packages—I'm not saying they are unavailable. They are available, and may be purchased separately. (Before the wedding, I don't dwell on proof sales. After the wedding, however, it becomes *very* important since, on average, each sets of proofs sold adds about $450 to 40% of the weddings I photograph.* It pays for the gas.)

* If you're interested in selling proof sets, see **Wedding Photography—Getting Clients to Return Their Proofs**. It offers a complete description of the system we use to market wedding proofs in addition to our other sales of albums and individual prints.

When The Previews Are Returned

> *During the time agreed upon for you to keep the Preview book(s), all orders for prints should be written on the included order forms. The Previews must be returned by the date agreed upon when the Previews were originally delivered, unless a new date is arranged.**

I think you'll agree that it's not terribly critical that the bride knows months in advance that she'll be writing her order on the order forms included with the proof books.

No, the key part of this section is in the next sentence: That at the time the Previews are checked out, a firm date will be set for their return. And this won't be an arbitrary date that I'll impose. Rather, it will be a *reasonable* date that the bride and I set together, after we've talked about it.

With this sentence in the Policies Statement, I am putting on the record that it's the bride's responsibility to keep appointments she has made. If the original appointment can't be kept, then it's again her responsibility to call and change the appointment. I'm easy. All I ask is that the bride call in advance when an appointment can't be kept.

Notice the asterisk. As before, it refers to the paragraph at the bottom of the Policies Statement in which I spell out the potential penalties when appointments are not kept. I take appointments seriously. Without this paragraph as part of my signed contract system, I could beg and plead for months, then still have nothing to fall back on should the ordering process stall. By having the policy that it's up to bride to reschedule, and linking prices to the fact that the bride follows this policy, I've closed the loop and achieved the intended effect: keeping the orders moving.

Adding a "potential penalty paragraph" of this type to your contract can be an amazingly effective tool for keeping assignments on track. With it, when proofs are late, you simply have to call the bride, and remind her 1) of the appointment, and 2) that keeping her "old" prices is dependent upon getting the proofs back pronto. If she questions your logic, you have but to have her refer to her copy of the contract. It's that simple. And it works!

While Your Order Is Being Completed

Within a few days after returning your Previews, you will receive a letter listing the individual orders and their total cost. The 7.25% California Sales Tax will be added to all orders. (It is recommended that during the time it takes for your order to be completed, you let people who ordered prints know the balance for their orders. Please have all checks made payable to "Steve Herzog Photography".)

On the Policies Statement, I want a brief outline of what takes place once the proofs have been returned. While the bride and I are going over her order, the paragraph above is the one I use to explain what she can expect next.

Within a few days of returning the proofs and the orders, the bride receives a letter listing every order written on the proof books' order forms. The letter gives the name of each person who ordered, and the total due for their prints. All orders are totaled, and deposits subtracted. A balance due is shown, which is the amount the bride will later bring with her when it's time to collect the finished orders. (This letter will be discussed more fully in the next chapter.)

Note that I make it clear that sales tax is added to all orders. I don't know why, but before I added this sentence, more than a few brides got upset with the fact that they had to pay sales tax. To make sure that brides don't think sales tax is either included in my prices, or not charged at all, I dropped this sentence into the Policies Statement. End of problem; I had something to point to.

The next section touches on a critical point: *it's the bride's job to collect the money from anyone who ordered pictures*. I don't want the bride assuming that somehow we will be tracking down "Uncle Bob", "Sally", and all the other good folks who wrote their names next to their orders on the order form. While we are busy at the studio having prints made and assembling albums, I want the bride to be busy getting the money together to pay for all those pictures as soon as they are ready.

Since we added this policy to the Policies Statement, we have dramatically shortened the time between when we notify brides that their orders are ready, and when they arrive at the studio, money in hand, to collect all the pictures. Brides take this policy in stride. Now, they understand that if they want to pick up their pictures quickly (and most do) they need to be collecting the money from friends and relatives *before* we notify them that the orders are ready.

That wasn't always the case. Years ago, a *typical* situation was for the bride to wait until our call saying "Your pictures are ready!"—and use that as her signal to *start* collecting all the money. It was frustrating for us (we wanted to be paid) and for her (she wanted her pictures).

With this policy, we don't see that happening anymore.

Upon Delivery Of The Finished Orders

As soon as your orders are completed, you will be contacted. Upon notification, you will be asked to collect all orders within two weeks. Please note: all orders from the wedding will be billed and delivered as a single order. There can be no separate deliveries or individual billings. The complete order will be delivered only after total payment has been made.*

This is the moment we've all been waiting for. At my studio, the time between when an order is placed and the finished prints ready for pick up is generally about two months. We try very hard to keep to this schedule.

When the orders are complete, we notify the bride. When most brides get word that their orders are ready, they only have to grab their purse (and the money due) and they're on their way to the studio to collect all the pictures.

At least that's the way we *want* things to go. Stressing this process means that 95% of the time, that's what actually happens.

But not *every* time...which is the reason for this two-week policy. The statement that the bride "will be asked to collect all orders within two weeks" is meant to establish a specific limit on how long we will hold orders after notification.

As I'm sure you'll agree, it's no fun sitting on orders, waiting for them to be picked up. First of all, it means that you have the bride's pictures, and she has your money; it should be the other way around. Second, you're responsible for those pictures' safekeeping while you have them. Third, you've got money tied up in prints, albums, etc.; to realize your full profit, you need to collect the payment balance. Finally, there's no reason you should be expected to keep orders longer than a "reasonable" length of time while the bride and groom use your money to do other things, and pay other bills. When you're asked to store their prints beyond a few weeks, you should be compensated for your time and trouble. After all, you're not in the storage business. And you're not a bank.

My solution comes with the wording on the Policies Statement. After two weeks, if we still have the orders, and haven't heard from the bride, the asterisk kicks in and the policy shifts to the paragraph at the bottom of the page. We start adding late charges and storage fees. It's not that we want this money. Rather, we simply want to motivate the bride to think seriously about picking up her order *very* soon.

As simple as it is, this policy does its job very efficiently. It generally takes but one phone call, and one reference to these late charges and storage fees, for the bride to make an appointment to pick up her pictures. When it comes to whether the additional charges are actually added, I have a choice: if she comes over quickly, I waive the charges. If not, I add them to the billing. Most of the time, the charges are waived—which is fine with me.

Please note: all orders from the wedding will be billed and delivered as a single order. There can be no separate deliveries or individual billings. The complete order will be delivered only after total payment has been made.

This section of the Policies Statement refers once again to the fact that all orders must be picked up, and paid for, at one time. We absolutely do not deliver part of the order one day, and then hold onto the rest of the order until a later date. As it was on the front of the contract, this policy is stressed whenever the subject arises—and even when it doesn't. I don't want there to be any misunderstandings.

I can't imagine that you, or any other photographer, would want to handle order deliveries in any other way. There's more to success, however, than merely adding this policy to your contract. No matter what you say on paper, some brides, when they call, are going to ask whether they can collect only *part* of the order. It's easy to undermine you own policy by telling brides, "Sure, come on over, pay for the pictures you take, and pick up everything next week". Do that, and I *guarantee*, you'll live to regret it. Just stick to your written policy. It's fair and reasonable. There's no reason to modify or abandon it.

Reorders

For reasons of consistency and print quality, and to reduce the chance of damaged negatives due to increased handling, it is best if all orders are placed at the time of the original order. However, negatives are kept on file for a minimum of one year and will be available for reorders. Prices of these prints will be computed as follows: the then–current price for the size of print(s) ordered, plus a 25% filing surcharge for special handling and reprinting. Color match with the original series of prints is not guaranteed. Reorders must be paid for in advance.

Chances are, reorders placed after the original order has been delivered are not one of your greatest sources of wedding revenue. It's not that there's anything *wrong* with reorders. It's just that considering the time involved in tracking down the dusty file in your garage, verifying that you've found the right wedding and the right negative(s), having the print(s) made, notifying the bride...well, it's easy for those one- and two-print reorders to become more trouble than they're worth.

Still, if it's your policy to keep the negatives, then it's part of your job to be ready, willing, and able to have prints made long after the initial orders are delivered. To establish the reorder policies we use at my studio, our Policies Statement covers several important points. Even before the wedding is booked, I want the bride to understand how reorders differ from the original order:

• Reordering prints means handling the negatives again. This increases the likelihood that "something will happen", such as negative scratches, etc. I

want brides to know that while we do our best to protect our film, the more it's handled, the greater the risk that the second set of prints won't come through looking as good as the first. By listing this fact on the Policies Statement, it gives us one more chance to encourage the bride to order any prints needed when placing the original order, rather than waiting until later.

• The statement that we keep negatives for a minimum of a year is somewhat misleading. Yes, they are kept for a year. And five years. And 10 years. Heck, I imagine that if I dug deep enough in *my* garage, I could find the negatives from my first wedding in March, 1974. Again, my reason for adding this sentence is to motivate the bride to order *now* (or at least within a year) rather than waiting until their 25th anniversary.

• We add a surcharge for reprints. As the policy states, the price for reorders is the price in effect at the time the reorder is placed, *plus* a 25% surcharge. This covers the added time required for tracking down the negatives, then handling what is usually a small order. By listing this surcharge on the Policies Statement, I have something, in writing, to point to when a bride asks what reprints cost. (If an order proves substantial, I can always waive the surcharge.)

• A cardinal rule for us with reorders is that they are paid for, in full, before we even start looking for the negative(s). When a bride contacts us about reordering, we figure the total amount due, and tell her we'll begin having the prints made as soon as we receive payment. Not surprisingly, only about half of the time does a check arrive in the mail. That's fine with me, since if the bride isn't willing to pay for those prints, I'd rather find that out before I track down the film and/or have prints made which are never picked up.

• The sentence dealing with color match is an important one, albeit one which doesn't come up very often. Here's the situation: when we send the original order to the lab, everything is done to make sure that the color and density of the prints are consistent across the entire order. But a year later, if a reorder sends one of those negatives back to the lab for reprints, the new prints will be made using different batches of paper and chemistry, and maybe different machines and operators. All those variables make it unlikely that the prints will match *exactly*. Both sets will look good, but if you put them next to each other, they won't match.

To head off problems, we're up front with people about color consistency. For most brides, a slight mismatch is not a problem. On the other hand, if we can see that it will be a problem, we then ask the bride to bring in a copy of the print from the original order. This print is then sent to the lab as a color guide.

* Footnote

Pricing for our services is guaranteed only when the above policies and procedures are followed. For weddings for which deposits are not paid on time, or Previews returned and orders not placed according to the agreed upon schedule, prices will be updated to reflect current prices at the time the order is finally placed. Late charges may also be added. For finished orders which are not picked up within two weeks of notification, additional handling and storage charges will be added to the balances due at the rate of $5 per week, beginning with the first day overdue.

No matter how fair and reasonable your policies, at some point your well thought out and worded guidelines will be ignored by a bride. She'll have her reasons, yet the fact remains that to get the order moving again you'll have to call in the cavalry for reinforcements. On my Polices Statement, that help comes in the form of the Footnote paragraph at the bottom of the page.

As you've seen in several places on the Policies Statement, the asterisk directing the bride's attention to the Footnote is triggered when she doesn't uphold her part of the agreement. The idea here is simple: when booking the wedding, I promise to lock in prices; even if the wedding is a year or more away, the prices will not change. This promise, however, is conditional. To keep those prices firm, the bride must follow through on her end of the bargain by keeping appointments to pick up proofs, return them, place orders, and pick up the finished prints and albums. As long as she does that, we'll get along fine. The Footnotes will never come into play.

When those appointments aren't kept...well, that's different. I've found it to be *extremely* effective when, for example, the proofs aren't coming back to simply pick up the phone. I'll call the bride, and say something like, "Mary, you had an appointment last week to return the proofs, and we've already rescheduled that appointment twice. If you'll look at your copy of the Wedding Contract, at the bottom of the Policies Statement on the back side, you'll see that our holding the prices quoted depends upon you keeping appointments. Since you originally booked your wedding 14 months ago, the prices in use now are about 15% higher. We need to make a new appointment now—and if you don't keep that one, we'll have to revise your pricing to what brides booking now are paying."

Thankfully, this is a call I rarely have to make. But, it does the job intended—and it does it very well. Yet without the Footnotes paragraph, there would be nothing I could do, really, if brides were skipping appointments, etc.

The same thinking applies later, when finished orders are ready, but the bride isn't. To rekindle her interest in picking up these photographs, we make a quick phone call to remind her that handling and storage charges will be added

to the balance—unless she quickly makes the trip over to the studio. Once again, this generally does the trick.

Finding Your Comfort Zone

As I mentioned earlier, the ideas we've been discussing are those which have evolved over time at my studio. They started out simple and disjointed, yet are now what I consider to be a rather tight and unified system for getting me—and the bride—successfully through the process of producing a set of wedding photographs. I've found my comfort zone.

Are the contract and policies I use the only way to approach the task? Of course not. While I know they work because they've proven themselves for me over hundreds of weddings, I'm sure there are policies you'll want to add or delete, or sentences you'll want to rework. It doesn't really matter what your policies are...*as long as they are fair and reasonable, you present them clearly, and you take the time to make sure your brides understand them.* That's what will make the difference between an ineffective and useless contract, and one which does the job intended.

Don't Let Exceptions Make The Rules

Before you hit the keyboard and start building your contract, a few words of caution: don't be in such a rush to build the ultimate, bulletproof contract that you forget about how it comes across to your prospective customers. There's much to be said for the concept of *finesse* in this situation. If you get misty-eyed when talking about wedding photography with the bride, then, when she's ready to book, you hand her a contract which reads like *Crime and Punishment*, there's a good chance that bride will seriously rethink how badly she wants to work with you.

I bring this up because, over the years, I've become a student of contracts used by other photographers. I've seen a lot of 'em. Most are positive in tone—they make the bride feel she's welcome. A few, however, have been some of the most amazingly negative pieces of writing I've ever seen. They make no effort to be friendly or helpful. They don't try to mask the idea that bad things can happen to brides who don't follow "The Rules". You can almost hear the photographer saying to the brides, "Dammit, I've had trouble with people like you before, and there's no way *anyone* from any wedding ever going to screw me over like *that* again!"

Personally, if I were a bride looking at a contract like that, I'd be a little nervous about adding my signature to the dotted line. Unless that photographer was the last one on earth (and maybe not even then), I'd make a point of finding a professional who didn't make me feel like a criminal.

Walk Softly (And Carry A Big Stick)

My recommendation: stay loose. Don't use your policies as weapons. Strong, effective, policies can be worded in such a way that the bride won't think she's risking life in prison, if she signs. She should feel *comfortable* working with you, just as you should feel comfortable working with her.

That's not to say you should be a wimp, either. Not all brides are going to like all of your policies. That's fine. That's *life*. Still, someone has to be in charge of the assignment—and when it comes to setting overall policies, that someone is you. *You can't let the bride dictate the policies for your business*. You have to be the one in control of the situation, calling the shots. That's just the way it is, and the way it has to be. If you don't do it, there will be chaos.

As long as you make sure the bride understands your policies, and make it clear that you take them seriously, I think you'll find the entire issue of enforcing policies and contracts to be a big non-issue. Yes, you'll have your occasional bride who questions everything and/or wants to rewrite the rule book after the game has started. Stand your ground...*with a smile on your face*. If necessary, get out the original contract and point first to the policy in question, then to the bride's signature. Talk it over. If your policies have been clearly stated from the start, are down on paper in writing, and the bride knows that she has previously agreed to them, *most* brides will elect to get on with it.

What about the inevitable bride who insists that her way is better than yours...no matter what the contract says? Well, that's a bit trickier. First of all, listen to her. Consider what she's saying. If she's right and has indeed found a better way, then thank her for helping you—and use this opportunity to improve your policies. If she's wrong and/or simply looking to have her way with you, then stand your ground. Above all, don't automatically abandon your own policies just because she wants it that way. You have your policies in place for a reason. You've done everything you could throughout the process to make your position clear. You've been fair and reasonable. At this point, you're within your rights to remove yourself from the discussion and let your contract do the talking.

In either case, we're talking about what amounts to only a very small minority of brides. In my business, since I started making a point of stressing the contract's importance, I can't think of the last time I had anything close to a major battle over policies. It just doesn't happen anymore. I've had skirmishes, and in each of those situations the bride and I have been able to find an amicable solution.

When it comes right down to it, I think you'll agree that most brides really are a very nice group of people to work with—as long as they're treated fairly.

Do that, plus back yourself up with a strong contract, and your problems should be few and far between.

Just like in the movies.

3

More Business Forms For Wedding Professionals

As important as the Wedding Contract and Policy Statement are, they're not the whole story. Not by a long shot.

The assumption here, and throughout the book, has been that you want assignments to go *smoothly*, from start to finish. While contracts and policies have their role, they aren't really set up for handling the day-to-day details that seem to take up so much time in this business.

This chapter will help you get control of those details.

The Devil Is In The Details

You remember your early days in business, don't you? There weren't many assignments, so it was easy keeping what few details there were in your head, or on random scraps of paper. This approach worked fine, for awhile. As you got busier, the details—and paper—multiplied geometrically. Systems that worked fine before, were now splintering under the load. Important details began falling through the cracks.

To survive, you had to adopt better "information management systems". You had no choice. If you didn't, you knew it was only a matter of time before you missed an appointment, forgot an order—or skipped a wedding altogether. It was either adapt, or die.

Even if you don't remember your early days, I remember mine. They were a mess; I was as disorganized as any of you reading this book. But I learned quick. It took only a few major screw-ups to realize that I couldn't keep my mind free to think about photography if I was constantly *distracted* by all the other vital, but non-photographic, bits of information. I had no choice but to monitor them—but I didn't have to *like* it.

I needed help. To make a long story short, my solution was to separate the *thinking* side of my business from the *mindless* side. I wanted to improve my photography, which meant I needed time to *think* about it. To find those hours, I wanted a quick, easy, and *foolproof* way to keep track of everything else: names and addresses, dates and times, who ordered what, etc. These details were important, and I couldn't escape them, yet at the same time the chore of tracking them was about as mindless a task as I could imagine.

The solution: *automate.* What I saw, week after week, was that most weddings follow a pattern. An assignment usually starts with a phone call, moves next into the booking and photography, and then finally through the ordering and delivery stages. Since these steps repeat themselves so consistently, managing them simply means connecting them with a series of steps and policies, written down on a series of forms.

Once it's set up, using the system is something like a child's connect-the-dots drawing. Move from one dot to the next, and before you know it, you've got a picture—and you didn't even have to think about it. It almost drew itself. *Mindless.*

A Few Forms Favorites

The forms we'll be discussing in this chapter are literally what hold my wedding business together. Each has a job to do and, together, they do most of my studio's informational heavy lifting. I couldn't (*wouldn't!*) want to operate without them.

Briefly, here's what we'll be looking at:

• *Wedding Information Page.* This form's role in life is tracking the up-front information about each wedding: who, what, when, where. (It's not necessary to ask the bride and groom *why* they're getting married.)

• *Wedding Call Record.* This form tracks the total number of calls received for each date, as well as where the referral came from, when the bride called, and whether she booked or not. This information gives you a way of knowing where your business is coming from—and where it's going.

• *Booked Wedding Log.* This is a specialized calendar which provides a quick summary of which dates are available—and which are booked. This is the first form to turn to when the phone rings with a bride asking if you're available for her date.

• *Wedding Day Summary Letter.* Immediately after the wedding, this is the letter that's sent to the bride and groom, telling them what (if any) money is due when the Previews are delivered.

• *Wedding Preview Check Out Agreement.* This is the form brides sign when they come in to pick up their proofs. Its job is making sure policies are understood—and that proofs and orders are returned on time. It also serves as a model release.

• *Wedding Order Tally Sheet.* This form is used for figuring out who ordered prints from which negatives, and what those prints cost. You'll use this information when organizing the orders you'll be sending to your lab, as well as for letting brides know who spent how much money on what.

• *Wedding Order Totals Letter.* Once the Tally Sheet is complete, the specific information on individual orders is relayed to the bride and groom via the Totals Letter. It lists the "official" amount due for each order received, as well as the overall balance to be paid, in full, when the finished prints and albums are delivered.

• *Wedding Order Delivery Receipt.* Before the bride leaves with her finished order, you'll want to confirm that all pictures are present and accounted for, and that they've been delivered in good condition. This form formalizes that process, and gets the bride's signature in the process.

• *Wedding Income Log.* Showing a profit is the name of the game. This form breaks each wedding down and provides your own personalized answer to wedding photography's oldest question: "Am I really making any money?" This form may leave you smiling or weeping—but it will tell the truth.

As a group, these forms cover a lot of territory. As you'll see, none are complicated or require a degree in rocket science to use effectively. All can be easily adapted to your business, and your way of working.

The Wedding Information Page

There's no better time to start gathering wedding information than when the phone first rings—and you're ear to ear with a bride asking a lot of questions.

The best way to get organized is to forget the idea of trusting these details to memory. Instead, make it automatic that when one hand is picking up the phone, the other is reaching for the pencil and paper. At my studio, the piece of paper grabbed is the Wedding Information Page.

As you can see from the illustration, the Information Page is meant to serve as the central data form for tracking names, dates, phone numbers, locations, etc. about an individual wedding. It's the typical set of questions all wedding photographers ask of their brides; I'm sure that you're using some variant of this form in your business right now. Collecting this information is simply a matter of asking the bride the right questions and filling in the blanks. When all the blanks are filled in, you have what you need to be in the right place at the right time, with your camera. And film.

The Information Page is kept right next to the phone. That way, you can start writing down the details the *first* time the bride gives them to you. If you don't write them down then, you'll have to ask all those same questions again when you meet. Do that, and you've told the bride you weren't paying attention on the phone.

The Wedding Information Page, Key Points

Most of the reasons for gathering information on the Information Page are self-explanatory. I'm not going to go into needless detail on these. There are, however, several areas on this form which are worth noting.

• *Date of initial contact.* I like to keep track of the date each bride first calls our studio about her wedding. It just takes a second to jot down this information. (This date is later transferred to the Wedding Call Record, another form you'll be reading about shortly.) I also make sure to note the price list I'm quoting as I answer questions about costs, packages, print quantities, etc. I've learned the hard way that it's very easy to lose track of these details...unless they are written down on each bride's custom Wedding Information Page.

• *Multiple phone numbers.* It's surprising how often bride and grooms' phone numbers change between the date they first call, and the date of the wedding. Needless to say, they don't often remember to tell their photographers of these changes. This means you should protect your lines of communication by making sure you have other numbers available which won't change: parents' numbers, work numbers, etc.

Date of initial contact _3-18-97_
Meeting Date _3/21/97_
Price List _6/3_

Steve **Herzog** *Photography*

Wedding Information Page

Wedding Date _Dec 6, '97_ **Time/Day of Week** _Saturday_
Location _Covenant Church_ **Address** _3134 River Rd - Westley_

Bride's Name _Paula Faucett_ Home Phone _322-5326_
 Address _2224 E. Central - Lodi_ Work Phone _324-4434_
Bride's Parents _Jim + Ilene Faucett_ Home Phone _681-8830_
 Address _916 Veneman - Turlock_ Work Phone _681-7214 Mom_

Groom's Name _Brian Anderson_ Home Phone _542-2815_
 Address _4009 Briggsmore - Stockton_ Work Phone _566-4249 p.m._
Groom's Parents _Phil + Gina Barnes_ Home Phone _310-537-2248_
 Address _1003 Princeton - Los Angeles_ Work Phone _310-538-4751_
 step-Dad

Photography of Bride *before* wedding—TIME _noon_ Special Notes
 Location _Church - downstairs_
Photography of Groom *before* wedding—TIME _∅_ | _Brian's parents_
 Location _After Paula's pix at Church_ | _divorced_
Reception _Fes Hall, starts at 3:30_ | _—_
 Location _corner 6th + Amos - Turlock_ | _Make sure get pix_
 | _of grandma Faucett -_
Address *after* wedding _2262 Nantucket Pl._ | _she made cake_
 Los Angeles 90010 | _—_
 | _Pix of Paula's sister_
New Home Phone _310-537-3906_ | _+ baby (over)_

Pictures for newspaper(s) _Bee - 1 L.A. paper - 1_

How did you hear about *Steve Herzog Photography*? _did Paula's sis's wedding 4/95_
Florist _Bobbe's Flowers_ Bridal Salon _Nicholson's_ Caterer _the Vineyard_
Other Suppliers _Events Plus - Coordinator_

Photography Coverage Selected: _6 hrs_ Price: $ _1840._ Add on's: _∅_
Hours Included: _6_ (from _noon_ a.m./p.m. to _6:00_ a.m./**p.m.**
Booking Deposit Rec'd: $ _1000._ Date: _3/21/97_ Balance: $ _840._
Second Deposit Rec'd: $ _840._ Date: _10/10/97_ Balance: $ _∅_
Post-Wedding: _7_ Ttl. hrs. from _12_ to _7_ Ttl. rolls _18/120_ Lab/Env. # _P38274_

© 1995 shp

The *Information Page* is the central form for tracking names, dates, phone numbers, and other wedding details. It's also used to record ongoing deposits and payments. Since this is an internal studio form, it's printed inexpensively as needed on a computer laser printer.

• *Address after wedding.* Even if brides don't know where they'll be living after the wedding, you should keep asking this question until they can give you an answer. (If you lose track of the bride and groom, you can always contact the parents. They *should* know how to locate their kids.)

• *Build a referral network.* The only way to know how brides are hearing about you is to ask. The brides are calling, which means that what they're hearing must be making a good impression. Are they hearing about you from past brides? The florist? Are brides' moms singing your praises? Your Yellow Pages ad? A display? Your brochure? Knowing what's effective (and what's not) will give you the confidence to expand on those marketing avenues which work—and dump those which don't.

• *Vendor reconnaissance.* It's smart, too, to keep track of which other suppliers your brides are using. Florists, caterers, limousine companies, dress shops, etc.—all of these companies are potential allies since you've worked together on the same weddings. Once you identify these vendors, after the wedding you can show the owners the pictures you've taken at *their* weddings. Sure they'll want to see them! Do that, and you've taken a big step towards setting up an informal, mutual referral network.

There's also a lot of information the bride will give you which doesn't fit on the front of the Wedding Information Page. That's why you'll leave the reverse side blank. It's here that you'll write down such bits of information as the fact that the bride's grandmother made the cake and wants a picture of herself standing next to it, or that the groom's parents are divorced and *don't* (!) want pictures of themselves standing next to each other. Whatever. The back of the Information Page represents 93.5 square inches of note-taking real estate. You shouldn't have any trouble filling it.

Dual Notebooks

If you're not already busy fielding calls from brides, then you'll find out soon enough that you'll go through a lot of Wedding Information Pages. Tons of them. As they starting piling up, you need a way to manage them.

The system we use is one that's quite simple to set up, yet very effective. All that's required is two 3-ring binders. Here's how we use them:

• The first notebook is used to store the Information Pages from *unbooked* weddings. As the calls come in, we fill out the forms, then add them, in no particular sequence, into the notebook. They stay there until either the wedding is booked, or the date passes.

• The second notebook houses the all-important Information Pages from *booked* weddings. When a bride pays the booking deposit, her page is *immediately* transferred from the first notebook into this notebook, which is divided into two sections. The first section is where we write down the wedding date on a custom calendar-like form we call the Booked Wedding

Log; this form is discussed later in this book. The second section is where the Information Pages are stored for any weddings which are booked, but not yet photographed. In this notebook, *the Information Pages are kept in date order.* This way, when turning to this section of the notebook, the first Information Page belongs to the next wedding scheduled.

It ain't high-tech, but this dual notebook system works amazingly well. As long as procedures are followed, there's no question which weddings are booked, and which aren't. When I have an appointment to meet with an un-booked bride, I take my unbooked notebook with me for these "wedding talks". The fact that my notebook is loaded with Information Pages is my subtle way of letting brides know that we talk with a lot of brides. Meanwhile, the booked notebook stays in the back room near the studio's main phone.

Just before the wedding, and once we're sure that all the details on the Information Page are still correct, both sides of the form are photocopied. These *copies* are taken to the wedding; the originals *never* leave the studio. If, at the wedding, additional information is supplied (for example: newspaper black and white photos or new addresses and phone numbers) that data is brought back to the studio and transferred to the original Information Page.

Once a wedding is on film, its Information Page is moved out of the notebook and into its own manila "pocket" folder. We use these folders for all weddings, and they're a great way of keeping all the miscellaneous paperwork from a wedding together and in one place.

When a wedding assignment is complete, its folder is stored, in date order, in a standard filing cabinet.

Wedding Call Record

To book a year's worth of weddings, you probably take calls from hundreds of brides. All ask basically the same questions about prices, availability, packages etc. Even though you know that only a limited percentage of these callers will actually become your customers, you dutifully answer their inquiries—and copy down what information they give you about their weddings on your Wedding Information Page.

What happens with these Information Pages is pretty predictable. If the bride books with you, you keep it. If she doesn't, it's trashed. Right?

That's a big mistake. While it's true that you're making your money from the brides hiring you, there's much to learn from *all* the brides curious enough about your photography to pick up the phone and call you. Like it or not, even non-booking brides are telling you something. You just have to learn what it is.

Information Gold Mine

The place to start is with those miscellaneous Information Pages you've been filling out every time you talk with a bride. Rather than keeping only those Information Pages from brides who book with you, keep them all. Not forever; just long enough to harvest a few pieces of informational gold.

You're going to manage your mining operation not by neatly spreading all those Information Pages all over the floor and trying to see what it all means. You need a way to move the information into a more easily digested format. *You need a form*—and, as you might have suspected, I just happen to have one handy. It's the Wedding Call Record, and it has the potential, over the long term, of becoming one of your most valuable strategic data gathering tools. Really!

Using the Call Record is simplicity itself. After you've talked with a bride on the phone, you'll transfer a few key pieces of information from her Information Page to the Call Record for her wedding date. Here's a translation of how you might set up each line:

• *Bride's name.* A first initial and last name will do fine. Still, even if the bride is only willing to tell you that her name is "Karen", and that she's getting married on June 21st, then that's enough to link her Information Page to her line on the Call Record.

• *From Where?* Next is a shorthand code for how each bride heard about you. Since space is tight, you'll want to come up with a compact system of identifying sources. Still, be specific when you need to be—especially when writing down the names of wedding-related merchants who are pointing brides your way. You want to know who these allies are!

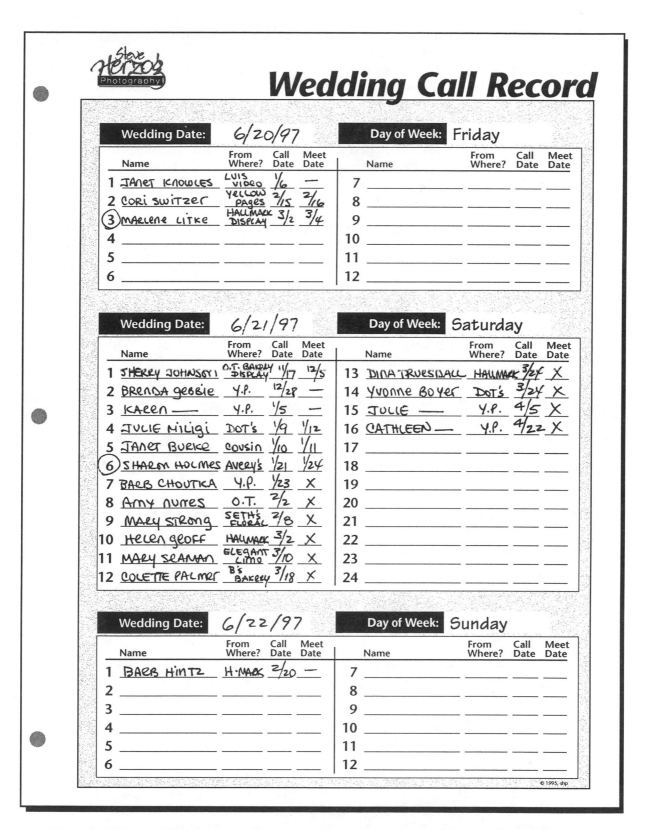

Wedding Call Record

Steve Herzog Photography!

Wedding Date: 6/20/97 **Day of Week:** Friday

#	Name	From Where?	Call Date	Meet Date	#	Name	From Where?	Call Date	Meet Date
1	JANET KNOWLES	LUIS VIDEO	1/6	—	7				
2	CORI SWITZER	YELLOW PAGES	2/15	2/16	8				
③	MARLENE LITKE	HALLMARK DISPLAY	3/2	3/4	9				
4					10				
5					11				
6					12				

Wedding Date: 6/21/97 **Day of Week:** Saturday

#	Name	From Where?	Call Date	Meet Date	#	Name	From Where?	Call Date	Meet Date
1	SHERRY JOHNSON	O.T. BAKERY DISPLAY	11/17	12/5	13	DINA TRUESDALL	HALLMARK	3/24	X
2	BRENDA GESBIE	Y.P.	12/28	—	14	YVONNE BOYER	DOT'S	3/24	X
3	KAREN —	Y.P.	1/5	—	15	JULIE —	Y.P.	4/5	X
4	JULIE MILIGI	DOT'S	1/9	1/12	16	CATHLEEN —	Y.P.	4/22	X
5	JANET BURKE	COUSIN	1/10	1/11	17				
⑥	SHARON HOLMES	AVERY'S	1/21	1/24	18				
7	BARB CHOUTKA	Y.P.	1/23	X	19				
8	AMY NURES	O.T.	2/2	X	20				
9	MARY STRONG	SETH'S FLORAL	2/8	X	21				
10	HELEN GEOFF	HALLMARK	3/2	X	22				
11	MARY SEAMAN	ELEGANT LIMO	3/10	X	23				
12	COLETTE PALMER	B's BAKERY	3/18	X	24				

Wedding Date: 6/22/97 **Day of Week:** Sunday

#	Name	From Where?	Call Date	Meet Date	#	Name	From Where?	Call Date	Meet Date
1	BARB HINTZ	H-MARK	2/20	—	7				
2					8				
3					9				
4					10				
5					11				
6					12				

© 1995, shp

The *Call Record* builds a history, *by date*, of every initial contact with brides asking about wedding photography. It lists names, where the referral came from, when the call came in, and whether the contact resulted in a meeting. A very helpful form! Printing is by laser printer.

(No matter what questions the bride has when she first calls, you should *always* ask her, "How did you hear about my photography?" It's the Mother of All Questions, and the answers you get are going to be some of the most vital you track on the Wedding Call Record. It's also an excellent way to turn the conversation away from questions about price, and towards questions about the photography, the wedding, etc.)

• *Call Date.* You want to know *when* the call came in. The dates written here will tell you how far in advance of their weddings brides are calling for information. (For reasons you'll see shortly, it's most helpful to log names on the Call Record in *date order.*)

• *Meet Date.* A date in this column means that the bride actually met with you to talk and look at samples. Even if she doesn't book, you want to separate this bride from other callers, since you came closer to booking her than, for instance, the price-shopping bride who calls and asks, "How much are your wedding pictures?"—then never calls back.

• *Winner's Circle.* At some point, hopefully, one of the brides listed on the Call Record for each active date is going to book with you. When that happens, you'll circle the number next to her name.

This process of transferring bits and pieces of information about individual dates should start with the first phone call you get on a date, continue right up until the date is booked—and keep going until the date is history. When the date is past, you'll have, on a single page, a snapshot of all the important information about any given weekend. Spread over 52 pages, you have a concise history of every phone call you got for weddings for an entire year.

Overkill? I think not. To prove my point, let's move on to the fun part of the process: analyzing the information, deciphering what it means, and figuring out how you can use it to improve your business.

Details By The Dozen

Don't expect the Call Record's value to become apparent overnight. At first, the isolated facts will be spread too thin across many Call Records to be immediately useful. But, over time, dates *will* fill in. Brides *will* book. Pages *will* be completed. Call Records *will* take shape as important documents you can put to good use by letting history point out what you need to do in the future.

When you've got a few months' worth of records, if you look carefully, you'll have the raw data you need to start asking, and answering, some very important questions:

• *How many total calls came in for each date?* Do more brides call at one time of year than another? During which months do more brides plan more weddings; which months the least? With this question on the Call Record,

you can move beyond simply having "a feel" for your busiest months, and simply count the actual number of calls coming in.

Or, to put it another way, is your phone ringing off the hook—or are calls so infrequent that it's hard to tell if you're in business at all? (It's difficult to build a business without customers. Getting the phone to ring is a vital first step. If you're getting too *few* calls, you need to put more effort into marketing and letting your community know that you're alive and well—and pretty darn good with a camera. If you're getting *more* calls than you could possibly handle, look for ways to keep your name in front of your prime prospects, while at the same time moving away from the brides who likely won't bring you top assignments. Also, you might reconsider your pricing structure. Most photographers drowning in calls are too cheap for the quality they're delivering—and the brides know it.)

• *Where are all those calls coming from?* Providing an accurate answer to this question is probably the most important job of the Call Record. Whether it's your Yellow Pages ad, referrals from wedding merchants, displays, or good word-of-mouth advertising—you need to know what's prompting brides to pick up the phone and call *you*. For example, is one of your fellow wedding merchants consistently referring brides who become your best customers? If so, you need to make a point of doing everything you can to make it worthwhile for him or her to continue sending you those brides. Don't leave it up to chance. A good way to start: make sure, at the wedding, that you get good photographs of the merchant's products in action. Zero in on the flowers for the florist. Capture the cake, alone, for the bakery. Create a stunning photograph of the bride's gown for the dress shop. Then, after the wedding, make sure you deliver copies of these photographs to each merchant personally—*and make sure your name is clearly visible on the front of each print.* Once the merchants see the connection between having you as the photographer and the fact that they get *professional* pictures of their products, in use by *their* brides, don't you think they'll want to see you behind the camera at future weddings? (Of course they will.)

Another valuable question from the *From Where?* line on the Call Record: Where is your advertising money paying off, and where is it wasted? If you're spending a lot of money on a Yellow Pages ad, this line on the Call Record will tell you, *positively*, whether the brides calling are a) booking, and b) worth the effort. Worse yet, is the Call Record telling you that you're having great luck booking sub-par weddings from the Yellow Pages—and then having to turn away brides who called from other sources which the Call Record is proving are always better weddings? (If so, I think you know what you can tell the Yellow Pages sales rep.)

• *Of the calls received for each date, how many brides liked what you told them enough that they made appointments to meet with you?* For each wedding booked, how many meetings did it take before a bride handed you a deposit check? Are you booking every bride, every *other* bride, or only one in six? (How you present information on your services has a major impact on whether brides will want to find out more about you. If brides are calling,

but few are scheduling meetings, you may be giving out too much information on the phone—especially *pricing* information. Save those details for later, at the face-to-face meeting. Instead of reading her your entire price list, tell the bride where your prices start, then invite her to a meeting to look as samples and discuss her specific pricing requirements. Scheduling this meeting should be your *real* objective on the phone.)

• *How early in the call sequence do you typically book weddings?* Do your Call Records tell you that you often get 15 calls per date, book the *second* bride—and then have to turn away the next 13? (Most photographers are in such a rush to fill their calendar that they jump to book the first bride who calls, forgetting all the brides who will still be calling over the next weeks and months. Just knowing, historically, that you average 17 calls per date for weddings during the peak season will help you avoid the pitfall of shooting your profits in the foot by booking an early caller wanting only a small coverage, then later having to turn away other brides who would have happily spent more. Once you can see, on your own Call Record pages, that you can be patient and hold out for the better weddings, you won't feel the urge to accept the first offer. Or the second.)

• *How many dates don't get booked at all?* Are there certain times of the year when you have no trouble filling a date—and other times when you're talking with brides, but few are booking? (If so, you might want to adjust your pricing for the slack periods, giving brides more bang for their bucks. Make it easier for them to book with you. Adding *value* gives you a better chance of landing an assignment. Or, just block off those dates, don't even try to book them, and schedule a vacation.)

These questions, and dozens of others, are the kinds you'll find answers to just by tracking a few pieces of information on the Call Record. The list is practically endless. Over the course of *several* years, you'll see that you have collected some really serious information. I'm willing to bet that over time, the Call Record will become one of the forms you turn to first, when you want to check the pulse of your wedding business.

I know that for me, the Call Record's long term value has been providing benchmark "scores", which I then try to beat. Instead of blindly doing weddings week after week, year after year, all the information I've compiled becomes another at bat, and a chance to improve my batting average. It keeps me sharp.

Best of all, those scores are from my business, my community, and my photography. This makes it much easier to gauge what effect changes make—and what changes make the most difference. There's no substitute for facts.

Since the Call Records are so crucial from a historical perspective, these are forms you should keep on file *forever*. They don't take up much space; a decade's worth of forms is only 520 pages—or about two large notebooks worth. They are definitely worth the shelf space.

Computer Slice And Dice

Even with a single notebook half-full of Call Records, you're still a long way from having the answers to all the questions a small collection of these forms can provide. Buried in the lines and columns is an enormous amount of valuable information; now, you only have to dig it out.

Naturally, you can unearth your answers the old-fashioned way: by hand, with pencil and paper. *But why?* Why put yourself through that agony when nowadays you've got ready access to tools specifically tailored to analysis and number crunching: the everyday computer. Simple database or spreadsheet programs can take all the facts on the Call Record, sort and organize them, and spit them back out in practically any manner you wish.

For example, the computer could sort all your records on the *From Where?* column, then give you totals by source—both for calls, and for eventual bookings. Or, it could point out which months bring in the most calls (from the *Call Date* column), or what percentage of those calls result in meetings, then bookings. If your program has graphics and charting capabilities, you could produce bar graphs or pie charts to show you how the facts play out. While you'll have to decide which information is worth tracking, I think you'll agree that your chances of using the data are much greater, *if* it's easy to find.

If you're tracking wedding *sales* on the computer, you can go even further. By merging your sales statistics with the information from the Call Record, you could, for example, take your sales figures and group them by the source of the original referral, then compute the average. You may be amazed to find out that the averages you're pulling from free referrals from past customers are far better than those you're getting in response to your (costly) ad on the back of the sales receipts at the local grocery store.

This is powerful stuff!

Booked Wedding Log

Once the bride has signed the contract, paid her deposit, and become "officially" booked, you'll need a fail-safe system for identifying that date as *off limits* to any future brides who call about the same date and/or time.

The trick here is in being able to find this information quickly—*and being positive it's correct and up to date.* When a bride does call asking about a date, you don't want to put her on hold while you sift through your stack of Wedding Information Pages, trying to decipher which dates are open, and which are booked. You need a way to instantly know what's going on in your calendar.

At my studio, the central form used to handle this important task is the Booked Wedding Log. As mentioned in the previous section, this form is kept in the front of the second of our "dual notebooks", the one holding Wedding Information Pages from *booked* weddings. When the phone rings for weddings, this is the notebook we grab.

The Booked Wedding Log is set up as a generic, fill-in-the-blanks calendar. As you can see from the example, dates are written along the left-hand side for Fridays, Saturdays, and Sundays. The forms are then 3-hole punched and added into the notebook in date order. In the notebook, we usually keep about 18 months ahead of the current date. As dates are booked, the bride's name, phone number, and photography start and finish times are filled in.

Two rules govern the use of the Booked Wedding Log:

• The Wedding Log is the first, and *only*, wedding "calendar" we use to track booked dates. This way, when a bride calls asking "Are you available for (date)?", there's only one place we need look to find an answer. Having more than one "official" place to log dates is an easy invitation to double booking, which is another way of saying, "d-i-s-a-s-t-e-r". (I don't mix weddings and studio assignments on Saturdays; it's either one or the other, so there are no conflicts. If a wedding is booked for a Friday evening, however, when studio assignments could cross over into pre-wedding preparation time, the date is first marked as booked in the Wedding Log—then those same hours are blocked off in the studio's daily appointment book.)

• We *never* waiver from this system. It's used the same way each time, every time. While the deposit check is still in hand, the Information Page is moved into the booked notebook, and the information needed about the wedding is added to the Booked Wedding Log. It's done as a single motion. When complete, that wedding is *officially* booked.

Whether or not you adopt the Booked Wedding Log, it's most important that you lock into a *single* date-tracking system. Keep it as simple, and foolproof, as possible. In other words, don't book one wedding one way, then experiment with another way on the next. Don't trust your memory. Find a system that works, use it consistently, then step back and let it do its job.

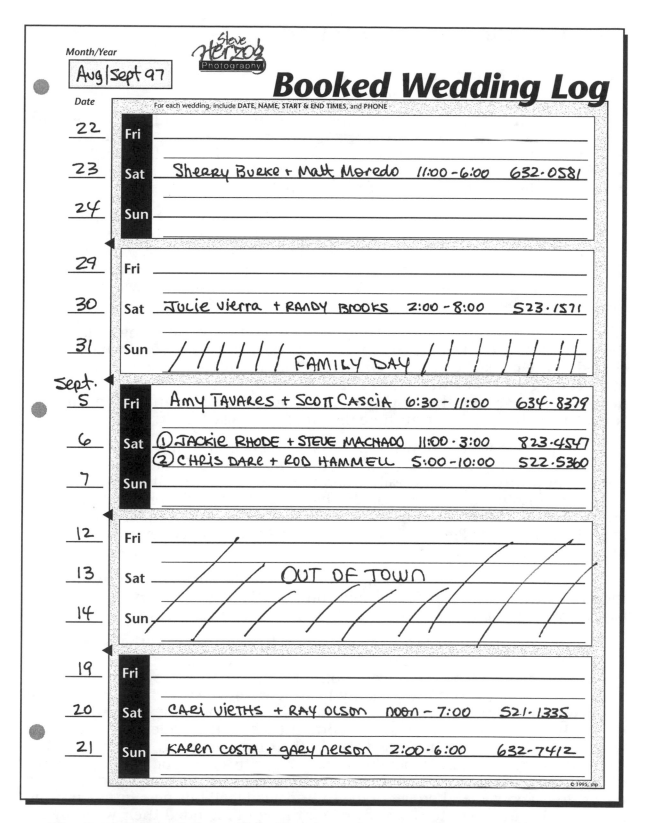

Month/Year

Aug/Sept 97

Steve Herzog Photography

Booked Wedding Log

Date

For each wedding, include DATE, NAME, START & END TIMES, and PHONE

Date	Day	
22	Fri	
23	Sat	Sherry Burke + Matt Moredo 11:00 - 6:00 632-0581
24	Sun	
29	Fri	
30	Sat	Julie Vierra + Randy Brooks 2:00 - 8:00 523-1571
31	Sun	///////// FAMILY DAY ////////
Sept. 5	Fri	Amy Tavares + Scott Cascia 6:30 - 11:00 634-8379
6	Sat	① Jackie Rhode + Steve Machado 11:00 - 3:00 823-4547 ② Chris Dare + Rod Hammell 5:00 - 10:00 522-5360
7	Sun	
12	Fri	
13	Sat	OUT OF TOWN
14	Sun	
19	Fri	
20	Sat	Cari Vieths + Ray Olson noon - 7:00 521-1335
21	Sun	Karen Costa + Gary Nelson 2:00 - 6:00 632-7412

© 1995, shp

The *Booked Wedding Log* is designed as a fast, accurate way to track which dates are available—and which are taken. The form is kept accessible in the front of the same notebook used to store Wedding Information Pages for booked weddings. Printing is via laser printer.

Wedding Day Summary Letter

Once the wedding is over and the last pictures taken, it's time to put away the cameras—and get back to business.

One of the more useful post-wedding habits you can cultivate is sending the bride and groom a letter summarizing precisely what happened at the wedding from a business/monetary standpoint. Before the bride calls asking, "When will the pictures be ready?", you need to notify her of what (if any) payments must be paid when those Previews are delivered.

The letter we use is romantically named the Wedding Day Summary Letter. Its job is to help us avoid the awkward situation of having the bride rush over to collect her pictures—but forget her checkbook. With the letter, when she gets the call that her pictures are ready and waiting, she knows ahead of time whether or not a payment is due. She knows, because this letter was waiting in the mailbox when she and the groom returned from their honeymoon.

The check the bride writes could be for any number of things. Maybe, at the reception, she asked me to stay an extra hour or two beyond what was included in the booked Coverage. Or, maybe the groom's grandparents decided at the wedding that they wanted to put a photograph of their grandson, and his new wife, in their local newspaper. As is stated elsewhere in my policies, all "extra" must be paid for at the time the proofs are picked up.

The paragraph dealing with newspaper prints is an important one. Before we began stressing this, I don't know how many times I made the requested number of prints, had them ready when the Previews were delivered—then had to go back into the darkroom to make the one extra copy the bride forgot to tell me about…until that meeting. By reminding the bride to think about newspaper prints before the Preview delivery meeting, the Summary Letter has cut back on the number of duplicate trips to the darkroom. Every little bit helps.

The Summary Letter also helps to finish up old business. For example, if the bride and groom had engagement photos taken, and haven't paid off the balance yet, that amount is listed as a "Previous Studio Balances."

To personalize what is essentially a form letter/invoice, at the bottom I've left room for a handwritten note. Adding a few words takes but a few seconds, yet it takes the edge off what would otherwise be an impersonal bill. There is always something about the wedding I can refer to, whether it's how nice the event was, or simply that I hope the couple found something interesting to do on the honeymoon. I feel this is important because the bride and groom just went through the most important day of their lives together, with me tagging along with my cameras. Hopefully, I made a positive contribution to the wedding. I don't want them looking forward to seeing the pictures, and thinking nice things about me, then get home to find a cold, all-business *invoice* waiting for them. I want them to sense that even though I attended their wedding on "official business", I still enjoyed myself and enjoyed sharing the day with them. *Usually*, that's the truth.

Bride & Groom: Lynn + Marty Kline
Date of Wedding: Oct. 11, 1997
Price List: 4|3 Coverage: 5 hr.
Hours at Wedding: from 1:00 to 7:00
Newspapers: Modesto Bee 1 Other 2
Date of Letter: Oct. 13, 1997

Steve Herzog Photography

Wedding Day Photography Summary

Dear Friends –

Before we call with the happy news that the Previews from your wedding are ready, we wanted to catch up on any new charges which may be due when the Previews are delivered.

For your wedding, those charges are as follows:

Original Bridal Album Coverage:	$ 1520.	(38 print album)
Additional Time at Wedding	304.	(1 hour(s) extra; add 8-8x10s per hr.)
Additional Newspaper Print(s)	24.	(2 extra print(s), $12 each)
	$ 1848.	Sub-Total: *Wedding Photography*
	– 1520.	(Less deposits paid to date)
Please note: These totals do not include the 7.25% California sales tax. That will be figured based upon the final balance, and collected when the finished orders are later delivered.	328.	Balance: *Wedding Photography*
	Ø	Previous Studio Balances
	$ 328.	Payment Due With Previews

It takes approximately two weeks from the date of the wedding before Previews are ready for delivery. We will notify you then. At that time, we will explain how to order the Bridal Album, Parents' Albums, and any additional prints. You'll be able to take the Previews home with you, and keep them for approximately two weeks while you, and your families and friends, make the selections.

Please be sure to check the above figure for the number of newspaper prints you'll be needing. If you need more prints than originally anticipated, let us know immediately. *If you have requested a print for the Modesto Bee, we will send that print directly to the Bee once we have the film back from the wedding.* (If you have not already returned a copy of the Bridal Information Form to the Bee, you should do that QUICKLY.) If you have requested additional black & white prints for other papers, those prints will be delivered at the same time you pick up your Previews.

In the meantime, if you have other questions, please refer to the *"Financial Arrangements & General Procedures"* section printed on the back of the Wedding Contract. (Copies of the contract and price list are enclosed.) If you have further questions, give us a call.

Lynn + Marty - Thanks for having me as your photographer. It was a great wedding! I hope you've had fun in Mexico. Call me when you get back. — Steve

The *Summary Letter* is mailed to the bride and groom immediately after the wedding. It's role is to inform the couple of any balances they will need to pay when the Previews are delivered, as well as check the status of black & white newspaper prints. Printed on studio letterhead.

Wedding Preview Check Out Agreement

After the wedding, when the call goes out to a bride that, "Your pictures are ready!", it's amazing how fast most can drop whatever they're doing, jump in the car, and be at the door ready to take those pictures home. From all appearances, you'd think there was nothing more important in their lives than taking the proofs, putting their orders together, and getting those finished albums delivered ASAP.

Appearances can be deceiving. While all brides want their pictures, not all are ready, willing, and able to follow a reasonable schedule. If your brides are typical, the reality of the situation is that instead of rushing to return the proofs and complete the order, it's more likely that once they know the pictures have "turned out", the proofs will gradually fade in importance. The bride will become busy with other things—and be perfectly content to hold on to the proofs until she finds the time to sit down, figure orders, and finally return everything so you can get busy having the prints made.

The result: proofs can sink from sight for months or years. By the time they resurface, the original enthusiasm has long faded. Money that was once earmarked for photographs from the "happiest day of our new lives together" has been reassigned to cover other, more urgent expenses like car payments, groceries, or the inevitable crib and toys in anticipation of the updated "happiest day of our new lives together".

All of this inactivity can have a severe impact on your income. Even if you wisely collected all the money due for the Bridal Album before the wedding, you can't just walk away from the added sales of Parent Albums, gifts for the wedding party, and prints from friends and relatives. In this business, those sales represent some of the highest profits you'll see. You won't, however, see any of it until the proofs are returned, and the orders placed and paid for. It's a fact of life that the longer it takes for the proofs to get back to you, the less those orders will total.

No, it's up to you to make sure a solid system is in place for getting clients to return their proofs, on time, every time. It's up to you to insist on a reasonable timetable. Verbal agreements aren't enough. You need the bride to agree on a return date—and then sign a mini-contract saying she understands your policies, agrees to them, and accepts that there will be penalties if the proofs are returned late.

At my studio, the form we've used for years to keep assignments on track is the Wedding Preview Check Out Agreement. I'm not overstating the case at all when I say that this form has single-handedly gotten hundreds of proof sets returned as scheduled while, at the same time, protected sales.

This is another one of those forms which is easy to set up, easy to use—yet has a huge, positive impact on how smoothly an assignment progresses.

Wedding Preview Check Out Agreement

Steve Herzog Photography!

In order to produce the Bridal Album, and additional print orders, within the shortest possible time, we require that Previews be returned no later than the date agreed upon at the time the Previews are delivered.

Name _Dina + Thad Crivelli_ Wedding Date _4-5-97_

Address _11706 East Ave, Oakdale_

Home Phone _672-4573_ Work Phone(s) _672-3247 (J)_

Number of Previews Delivered _164_ Date Delivered _4-18-97_

Preview Replacement Cost: $10.00 each (Total Value: $ _1640._)

© 1995, shp

I agree to the following:

- I agree to return all Previews no later than the date below, and understand that a Late Charge* will be added to the final balance if the Previews become overdue. I also understand that Previews not returned, or not returned in original condition, will be billed as per the "Preview Replacement Cost" listed above.

- I understand that all prices quoted when *Steve Herzog Photography* was first contracted are *guaranteed only if the wedding Previews are returned by the due date listed below.* If the Previews are returned after this date, I understand that all album and print prices will be updated to the wedding price list in effect at the time the Previews are returned.

- I understand that all Previews, negatives, and Preview Albums are the sole property of *Steve Herzog Photography*, and are not included in the price of the quoted Coverages. I further understand that all photographs are fully copyrighted, and may not be copied in any manner.

Preview Due Date: _Friday_ (day) _5/9/97_ (date) _3:00_ a.m./p.m.

Previews Received By: _Dina Crivelli_

***Late Charge: $15 per week overdue, added to final balance.**
(Late Charges will accrue until all Previews are returned. After four weeks, overdue accounts may, at our discretion, be referred to our collection agency for payment.)

To Avoid Late Charges: If You Cannot Keep This Appointment, Please Call Our Office Before The Due Date To Reschedule.

Model Release: ☑Yes ☐No

For value received and without further consideration, I hereby consent that my photographs may be used by Steve Herzog Photography for the purpose of illustration, video, exhibit, advertising or publication.

Bride: _Dina Crivelli_ date _4/18/97_

Groom: _Thad Crivelli_ date _4-18-97_

The *Check Out Agreement* locks in a specific date and time for the wedding Previews to be returned. It also serves as a model release form, permitting use of the photographs in advertising, displays, etc. The actual form is sized to print 2-up on standard 8½x11" 2-part NCR paper.

Wedding Preview Check Out Agreement Highlights*

The Check Out Agreement is, by design, a no-nonsense form. At my studio, when the bride arrives to pick up her proofs, and after she's looked over the pictures and asked her questions, this is the form she signs before she and the proofs walk out the door.

For the most part, the policies listed on the Check Out Agreement were discussed months earlier when the bride and I went over the Wedding Contract and Policies Statement. That was then; this is now. Since placing the orders is the moment *I* have been waiting for, I want everything to go smoothly, and without any real, or imagined, misunderstandings.

The Check Out Agreement does introduce several new policies that weren't included in the original, pre-wedding contract. Here's how we use them:

Preview Replacement Cost

It's important the bride understands that the proofs are, in and of themselves, *valuable*. I don't want her assuming that my proofs are just fancy snapshots, and worth the same 39¢ apiece she pays for prints at the drugstore. To establish the proofs' value, we have listed the "replacement cost" at $10 per print. If , for example, a set of proof books is loaded with 200 prints, and the bride sees that the Total Value is pegged at "$2,000", most quickly appreciate that they'd better not let Fido chew on the photography. I want these prints treated with respect. $10 per proof usually does the trick.

Another reason we make such a conspicuous display of the proofs' value is because we sell those proofs, *as a set,* for quite a bit of money. To establish the "fair market value" of the proofs, the bride needs to see a "list" price, which we then discount substantially if the proofs are purchased.

Preview Due Date

When it comes to setting the date proofs will be returned, I let the bride call the shots. She tells me how long she believes it will take for everyone to see the prints, place their orders, and have everything ready to return to the studio. With most weddings, two or three weeks is sufficient; it's rare for the bride to ask to keep the proofs longer than a month.

Once we've agreed upon a date and time, it's written down on the Check Out Agreement. To get the point across that this is a *serious* appointment, I stress that it's important for the bride to notify the studio if the appointment cannot be kept. It's her responsibility. If she doesn't keep the appointment, and doesn't notify us, I politely tell her that late charges will be added to her order.

* My book, **Getting Clients to Return Their Proofs** deals primarily with the issue of "proof management" and the Preview Check Out Agreement. If you're having trouble in this area, this book will help you make those hassles a thing of the past.

Late Charges

The late charge we've settled on is $15 per week. It's not so high that it comes across as extortion, yet it is substantial enough that it gets brides' attention. That's what we want. We do not use late charges as an excuse to collect $15. I'm not interested in nickels and dimes.

The main reason we employ the late charge is because I want those orders in hand before they go stale. Most brides, however, are interested in avoiding additional charges. Because she signed the Check Out Agreement, and understood our policies when she left with the proofs, if the appointment is missed, it usually takes one simple phone call to get a new appointment on the books.

A typical call goes something like this: "Julie, it looks like you missed your appointment. We really do need to have the Previews returned, since we've already scheduled your printing with our lab. If you can get them back to us by the end of the week, we won't have to add the late charges to your order." As long as it's done in a friendly and helpful manner, this call generally gets the proofs back quickly—and gets the order back on track. That's the important thing.

There are times, however, when even a friendly and helpful phone call doesn't work. The proofs were late, are late, and they're getting later. If the bride appears to be making no effort to bring the proofs back, we have no problem adding the late charges to her eventual order total and possibly bumping her overall pricing structure up to current levels. What else could we do?

Model Release

While most of the wedding contracts I've seen have the bride and groom sign the model release upon *booking* the wedding, and before the pictures have been taken, it seems more logical to ask for the release *after* the wedding. That's why we've included our model release on the Check Out Agreement. (You're missing out on a golden marketing opportunity if you're not having couples sign model releases. With the release, you have their permission *in advance* to use their pictures in advertising, displays, or whatever. And in photography, showing the product is what it's all about.)

You'll notice, too, that it's optional. Again, I don't like forcing people to give me permission to use their pictures. They may have good reasons for not wanting their pictures shown around town. I respect that. (Besides, introducing the model release provides another good opportunity for me to tell them how pleased I am with the pictures—and what a great job they did with their wedding. People like to hear that, especially just before they'll be going home to finish spending what may amount to several thousand dollars on photography.)

Wedding Order Tally Sheet

One of the least exciting chores in wedding photography is pouring over the proof books, trying to figure out who ordered what, then collecting all the negatives for their trip to the lab. It's a monotonous, largely thankless task—but somebody's got to do it. Chances are, that someone is you.

While it will never be a *fun* job, keeping results organized and accurate is definitely in your own best interests. (You and I both know what a hassle it is having everything about an order correct...except that one 8x10 that was mistakenly ordered, and printed, as a 5x7. It stops an order dead in its tracks.)

Non-Automated Automation

Getting orders to the lab right, the first time, is a priority at my studio. To accomplish that, the form we use is the Wedding Order Tally Sheet. As you can see from the example, the Tally Sheet is pretty straightforward. When a set of proof books has been returned, this is the form we enlist to log the "official" totals (money and prints) for anyone placing an order. Here's how it's used:

• The top section is for identifying any prints going into the Bridal Album *only*. As we go through the order forms in the proof books, the Preview numbers are written down according to what sizes are needed. When done, we add up the number of prints ordered for each size, then use the price list to compute the final totals on right-hand side of form.

• At the same time we're logging prints for the Bridal Album, we're also writing down any other orders in the second section of the Tally Sheet. This could be anything from large Parent Albums down to the single 5x7 ordered by the bride's sorority sister. We write down everyone's name, then, just as with the Bridal Album, go through and total all the orders. If the bride and groom are ordering prints that will *not* be included in the Bridal Album, those orders are kept separate in this section.

• The column along the right side is where the individual dollar amounts are written. In keeping with our policy that individual orders are viewed *only* as part of a larger overall order, we total all individual orders to arrive at a "Grand Total" figure. From this amount we subtract the deposits the bride has paid. What's left is the balance due when the finished prints are delivered. (In the past, we used a calculator to figure these totals. Now, we let the computer do the job. We'll discuss that next.)

• Once the Tally Sheet is complete, all the names and totals are used to fill in the blanks of the Wedding Totals Letter we send to brides. This letter, and how it's used, will be covered in the next section of this book.

• At the bottom of the Tally Sheet is a small area used for note taking. Here we keep track of what's going on behind the scenes as the order progresses:

Wedding Order Tally Sheet

Bride & Groom __KAREN + TIM GARDNER__

Wedding Date __5/14/97__ File # __97·23__ Price List __4/3__

Steve Herzog Photography

Bridal Album

5x5	5x7	8x10	Other
4,8,14,18 32,35,36,37 78,83,89,95 ⑫	56,63 74,90 83,92 ⑥	3,8,10,13,15,17,19,22,23, 24,28,38,40,43,51,54, 61,66,69,70,72,75,81,85, 91,95,102,106,110,114, 122,126,128,131,135,142, 154,160 ㊳	#70 11x14 (FREE) — cover 22

Bridal Album Totals w/ Tax

$ 1520. Booked B.A.

135.

162. Other

$ 1948.73 Total w/ Tax

© 1995, shp

Additional Orders

Name	5x7	8x10	Other	Add'l Order Totals w/ Tax
K's PARENTS	4,14,18,20,38,40,43 47,54,61,70,95,105,110, 113,122,126,128 ⑱	22 95 ②		$ 480.48
T's parents	32,95,114,135,142 ⑤	66 ①		187.69
gramma K.	40,95,105 ③			86.87
Susie	81 ①			28.96
UNCLE JOHN	115 ①			28.96
KEITH FAMILY	2 - #120 ②			57.92
WED. PARTY	4 folios #61 + #8			128.49

__6/24__	Negs to Retoucher	
__7/2__	Negs Sent to Lab	
__6/24__	Totals Letter Sent to Bride __8/26__ Promise Date	
__8/22__	Bride Notified Order Ready	

TOTAL $ 2948.10

Less Deposit(s) 1520.00

BALANCE $ 1428.10

Moving orders out of the proof books, and into a format where they are listed by *name* is the *Tally Sheet's* job. This information is then used to generate totals and, later, lab orders. At the bottom is the area used to track each order's progress as it works its way to completion. Laser printed.

when negatives went to the retoucher, to the lab, etc. Unless this information is written down, it's too easy to lose track of these details.

The Tally Sheet, in one form or another, has been used at my studio since I first started doing weddings. It's been a loyal, hardworking form. If you're still doing all your order processing manually, then a form of this type will do the job for you.

Out With The Old, In With The New

Unfortunately, organizing orders and negatives is *not* one of those jobs that gets easier as you do more of them. The busier you become with weddings, the more interested you'll become in finding a way to relieve yourself of some of that order tallying drudgery.

And you're in luck. The tool you're looking for is that common business appliance, the computer. It opens up a whole world of possibilities for making quick work out of monotonous, largely mindless tasks. Instead of you doing it all yourself, you delegate. It's like putting your calculator on steroids.

If you're a computer user, then you already know what I'm talking about. If you haven't yet taken the plunge, then here's a brief tour of how we use our antiquated Macintosh IIci to whittle down the time it takes to total orders and ready negatives for the lab, from several hours into an hour or less.

• Our system is not *completely* computerized. I still find it easier to start with the Tally Sheet, and go through the proof books by hand, writing down only the names, proof numbers, and quantities. (I've tried doing the original order entry with the computer, but it's too clumsy trying to flip pages and use the keyboard and mouse. Sometimes, paper is better.)

• Once the orders are logged, the computer takes over. Using a simple database program and template, I work my way through the Tally Sheet transferring information. For an average sized wedding, these first two steps take maybe 20 minutes, tops.

• Now the fun begins. Instead of manually totaling those orders, with a few keystrokes, the computer sorts the data by *name* and *negative number*. These instructions are set up as macros within the database, which means they can be played back for any wedding, and automatically give the results.

• The name sort provides the dollar totals for each person who wrote an order on the Tally Sheet. The computer looks up the price of each size print, multiplies that price by the total number of prints ordered, and produces a total. It then adds the sales tax and lists the exact amount each person owes for the pictures ordered. When the results are in, these totals are transferred back onto the Tally Sheet.

• Sorting by negative number is the real time-saver. Without changing anything about the data, the computer first sorts the negatives into numerical

order. Then, for each negative, it finds how many prints were ordered and in what sizes. This takes only a second or two. To get this information into usable form, I have another template set up which formats this information to fit on standard 1x4" pressure sensitive mailing labels. To get the order ready for the lab, all I do is run the labels, then affix them to the proper negative glassine.

• To complete the order, the last step is having the computer supply the total number of prints ordered from each size. I add this to the lab order envelope, and prepare everything for shipment. With that, the job is done.

Taking The Custom Route

As helpful as I've found this system, I must admit that it's still rather basic. I use my database program for many jobs around the studio, so I'm comfortable setting it up to do what I want. Not everyone feels this way. If you're part of this later group, and simply want the computer to supply the answers without having to worry about setting up the questions, you should investigate some of the custom software on the market designed specifically to fully automate the entire wedding order process. Or, an entire business.

Finding the names and distributors of these programs is not difficult. Many database companies advertise monthly in magazines such as *Professional Photographer*, *The Rangefinder*, and *Studio*. With many programs, it's possible to get "demo" copies which let you test drive the software. Demos are crippled in some way; maybe they won't print, or you'll be able to enter only a limited number of records. Still, you'll get a feel for the software and be able to see whether it meets your needs. If so, the next step is obvious: you buy the full version.

Another way to check out software of any kind is by talking with other professionals who are computerized. It's common these days, so you shouldn't have any trouble finding people using the type of software you're considering. An advantage to talking with veteran users is that you'll learn whether the software really does all it promises.

No matter what computer or software catches your eye, the point is that the technology is here now to help you run a tighter, more profitable, more organized, less time-consuming business. And, this technology is affordable. The ideas I've touched on here are only the tip of the iceberg. There are scores of additional duties perfectly suited for computers: desktop publishing for price lists, brochures, time management and scheduling, graphic design for logos and other artwork. You name it.

Take advantage of it!

Wedding Order Totals Letter

Once you're through tallying orders and know who wants what, the next step is quickly getting an official listing of these orders into the bride's hands. She needs to know the exact dollar amounts people owe so she can begin collecting payments, which she'll hold for you until the finished prints are ready.

At my studio, we try to make this very important job as easy on the bride as possible. Rather than mailing her an impersonal invoice such as she'd get from the service station when she has her oil changed, we prefer to write her a *personalized* letter on the studio letterhead.

Actually, it's the computer that (again) does most of the work. The letter shown is actually a standardized template file that's reused with each wedding. The formatting is set. To print the letter, the names, dates and dollar amounts are brought in from the Tally Sheet—and "Print" is pushed on the keyboard.

The upper section of the letter is self-explanatory. Here we list the names of people ordering pictures *exactly as they were written* on the order forms. Since we're working through the bride, we don't need to know who they are. As long as the bride knows, that's all that's important. At the bottom of this section, the individual orders are totaled, deposits subtracted, and the "Balance Upon Delivery" is listed.

The next paragraph goes on to restate a few of the main policies in play at this point. The sales tax issue is again raised, and clarified. Then comes the reminder to the bride that while we're making the prints, she should be collecting the money. We want her to be ready when we are.

The last paragraph before the signature is designed to cut down on the number of calls asking "Are my pictures ready yet?". We've been doing weddings long enough that we know, plus or minus a week, how long it will take to complete an order. Now that we've got the proofs back and the negatives are on their way to the lab, we feel confident in committing ourselves to a specific delivery date. We generally allow ourselves a total of six weeks after the date on the letter, except in the fall when we'll stretch it out to eight weeks, just to be on the safe side of the high school seniors/holiday rush.

The "P.S." is conditional. If the bride has already purchased the Previews, or if she's told us she definitely *doesn't* want them, the computer is instructed *not* to print this paragraph. If the proofs are still up for grabs, then we use the P.S. to remind the bride that they are *definitely* still available.

This letter is mailed out as soon as possible after the proofs are returned to us. Unless we, or the bride, have any questions, this is the last contact we'll have with the bride before she's notified that her orders are ready for pick up. The letter usually does a good job. When the call goes out that it's time to come for the prints and albums, most brides waste no time getting to the studio with their handful of checks. Smooooooth…

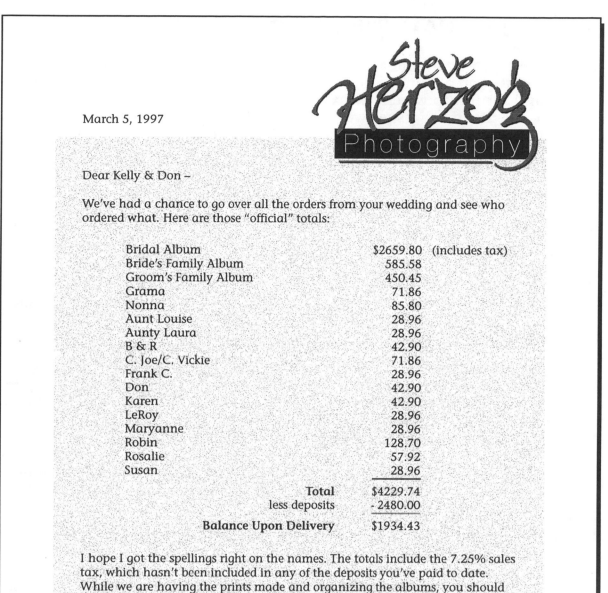

March 5, 1997

Dear Kelly & Don –

We've had a chance to go over all the orders from your wedding and see who
ordered what. Here are those "official" totals:

Bridal Album	$2659.80 (includes tax)
Bride's Family Album	585.58
Groom's Family Album	450.45
Grama	71.86
Nonna	85.80
Aunt Louise	28.96
Aunty Laura	28.96
B & R	42.90
C. Joe/C. Vickie	71.86
Frank C.	28.96
Don	42.90
Karen	42.90
LeRoy	28.96
Maryanne	28.96
Robin	128.70
Rosalie	57.92
Susan	28.96

Total	$4229.74
less deposits	- 2480.00
Balance Upon Delivery	$1934.43

I hope I got the spellings right on the names. The totals include the 7.25% sales
tax, which hasn't been included in any of the deposits you've paid to date.
While we are having the prints made and organizing the albums, you should
be telling people what their balances are; when we let you know that
everything is ready, all the orders will be paid for and delivered at one time.

Call us if you have any questions. As soon as all of the pictures are ready,
which should be around April 16th, we'll call you right away.

Thanks,

Steve

P.S.— Be sure to tell us if you'll be purchasing your Previews. We keep Previews
on file for only a few weeks after finished orders are delivered, just to make
sure that everything is correct.

**The *Order Totals Letter* is mailed shortly after the Previews have been
returned and orders placed. It's job is to provide exact sales totals for
each person ordering, so the bride can begin collecting payments. The
letter is computer-generated, then printed on the studio letterhead.**

Wedding Order Delivery Receipt

One of the more enjoyable aspects of wedding photography is delivering the finished prints and albums to brides. It's the moment the bride has been waiting for, and it's fun to watch her expressions as she goes through her wedding album for the first time. If she owes a balance, it's also fun to be paid.

I don't know about your business, but for many years my routine was to deliver the albums—then wave good-bye as the bride walked away with her armload of pictures. For the most part, everything went off without a hitch.

Still, every so often, after the "final" delivery, the phone would ring. It was the bride, excitedly telling us, "We can't find the 5x7 of Aunt Helen". Or, "I got home with the prints, and found a scratch on one of them." Or, "My mom says she ordered a picture of us next to the cake, but that's not the one she says is in her album." Next question: "What are you going to do about it?"

Most of the time, there was nothing we could do but reprint the allegedly missing/damaged photographs. We took the calls at face value, since we had no way of proving otherwise. I just ate the added cost, and put up with the hassle.

But I didn't like it. The overdue solution was simple: instead of waiting for the bride to call *after* the prints had been delivered, we redoubled our efforts to make sure everything was correct *before* the prints left the studio. The form used to oversee this feat is the Wedding Order Delivery Receipt. Now, at album delivery time, we go through a set series of steps:

• Before the bride arrives, double check that not only are all the prints present and accounted for, but that none are scratched or dinged. If the order is particularly complicated, a second person also checks the order.

• With the bride, we go through all orders and compare what's being delivered with what was ordered. Additionally, even if the proofs are purchased, we keep the proof books intact, with order forms in place, at the studio, for two weeks to make sure that if any questions do arise, we have the original orders together.

• Once the bride is satisfied with the status of the orders, she's asked to sign the Delivery Receipt. With it, she is telling us everything is correct and "as ordered." Her copy also serves as her receipt for the final payment.

All in all, formalizing the delivery process with the Delivery Receipt adds very little time to this important last step. But it does the job it was intended to do. Not surprisingly, the number of post-delivery "problem calls" is way down.

And when brides do call with a question about their orders, it's nice how polite they are now, when asking for our help.

Wedding Order Delivery Receipt

Name _____

Wedding Date _____

$ _____ Grand Total for All Orders

_____ (less deposits paid)

$ _____ Balance Received Upon Delivery

I have inspected the finished albums and photographs and agree that the order is complete and in good condition.

Studio Representative Date

Signature Date

© 1995 shp

Wedding Order Delivery Receipt

Name _____

Wedding Date _____

$ _____ Grand Total for All Orders

_____ (less deposits paid)

$ _____ Balance Received Upon Delivery

I have inspected the finished albums and photographs and agree that the order is complete and in good condition.

Studio Representative Date

Signature Date

© 1995 shp

Wedding Order Delivery Receipt

Name SANDRA + LARRY PEARSON

Wedding Date 7-26-97

$ 2089.26 Grand Total for All Orders

1740.00 (less deposits paid)

$ 349.26 Balance Received Upon Delivery

I have inspected the finished albums and photographs and agree that the order is complete and in good condition.

Steve Herzog 10/17/97
Studio Representative Date

Sandra Pearson 10/17/97
Signature Date

© 1995 shp

Upon accepting the finished albums and prints, the bride signs the _Delivery Receipt_ **to acknowledge that all orders are complete and in good condition. This form also serves as the receipt for the final payment. Printed on 3-up on 2-part NCR paper, then cut and padded.**

Wedding Income Log

You've booked the wedding, taken the pictures. The bride has brought back her proofs and placed her orders. You've totaled the orders. You've delivered them. Now it's time for the Big Question: *Did you make any money?*

To answer that question, the form to turn to is the brutally honest Wedding Income Log*. When all the blanks are filled in, it spells out exactly where a wedding's profits are coming from—or *not* coming from. It also does a good job of identifying problem areas, or areas that should be emphasized more in the future. It's all there.

Anatomy Of A Wedding

Using the Income Log is an exercise in reverse engineering. It's easy enough to figure a wedding's overall gross profit just by subtracting costs from the total listed in the bride's Totals Letter. Since you want to know more than that, you'll need to dissect the order into its various parts. You want to know what made a wedding tick, or why it died. That's the only way to learn.

Looking at the sample Income Log, you can see that along the left-hand side, the individual orders have been subdivided into several categories. In my business, these are the groups I want to track; I want to know how much income each generates, what the cost is, and how it compares to the others.

• *Bride and Groom.* If no one ordered any *additional* prints, what would profits be if the Bridal Album, *as booked,* was the *entire* sale? Since it's the Bridal Album which must absorb a wedding's up front costs, I want to make sure I'm not giving away the Bridal Album just to have a shot at selling extra prints to relatives and friends.

I also want to track, and separate, any extras the bride and groom purchase above and beyond the booked Bridal Album. This is where the real profits start materializing. I want to know as much as I can about where those sales came from, so I can make it happen again with *future* weddings.

• *Parents.* I'm always looking for ways to produce a series of pictures which parents will want in an album, rather than as a pile of loose prints. As I'm sure you have, I've seen how the sale of two Parents' Albums can, dollar for dollar, generate a much higher return than a basic, no frills Bridal Album. To make sure I don't ignore these dear people, parents' orders are very closely monitored.

* For a complete discussion of the Wedding Income Log, please refer to the most recent *second* edition of my first book, ***Wedding Photography—Building A Profitable Pricing Strategy.*** The entire book is geared solely to pricing and getting the numbers on the Income Log as high as possible. An entire 40 page chapter is devoted to tracking income, expenses, and profits.

Wedding Income Log

Steve Herzog Photography!

Wedding **Lowe/Feldman** Date **7/12/97** Day of Week **SAT**

File # **97-32** Price List # **6/3** Location **B'nai Israel** Date Booked **11/14/96**

© 1995, shp

	Income	Cost	Gross Profit	Mark Up
Bride & Groom	$	$	$	%
21 rolls film @ $**3.50**/roll	—	312.	—	—
46 Print Bridal Album as Booked	1840.	361.	1167.	510 %
Sub-Totals **Bridal Album as Booked**	1840.	673.	1167.	274 %
1 Add'l Hours @ $**320**/hr.	320.	54.	266.	593 %
1 Add'l Prints for Bridal Album	FREE	7.	(7.)	—
196 Previews Bought as Set	686.	—	686.	N/A
Other **3 pages 5x5**	108.	27.	81.	400 %
1 - 16x20	FREE	38.	(38.)	—
Brides & Groom's Totals				
Parents				
26·5x7 Print Parent Album/Bride	546.	139.	407.	393 %
2·8x10 **4·5x7** Print Parent Album/Groom	188.	23.	166.	836 %
Other **B.P. - 1 - 11x14**	180.	16.	164.	1125 %
Parents' Totals	914.	178.	737.	515 %
Friends/Family **1-8x10, 7·5x7**	229.	26.	203.	872 %
CANVAS BKG **7·8x10, 12·5x7**	604.	73.	531.	830 %
Friends/Family Totals	833.	99.	734.	841.%
Miscellaneous **Wed Party · 6 FOLIOS**	180.	30.	150.	599 %
The Bottom Line	$ 4881.	$ 1105.	$ 3776.	442 %
	Total Income	Total Cost	Total Gross Profit	Average Mark Up
Reorders **2-8x10 , 3·5x7**	161.	20.	142.	826 %

Hours...
Invested Before Wedding **6**
Invested On Wedding Day **9**
Invested After Wedding **18**
Total Hours to Complete **33**

Hourly Gross Income From This Wedding

$ **114.42**

Notes
- TOOK CANVAS BACKGROUND
- STARTED THINKING MULTI-SHOT SEQUENCES!

Gross sales aren't as important as gross profits. The *Income Log* is designed to break an order down, separating the money into where it's coming from…and where it's being spent. It does this for the entire assignment, as well as the primary sub-categories. Laser printed.

• *Friends/Family*. Again, these orders are almost pure profit. At the wedding, I do everything I can to identify anyone who might want, and *order*, pictures. With this section, I learn whether it was worth the effort. So far, it has always paid off handsomely. (Even if many of these pictures aren't purchased, I've learned that taking them increases the value of the *proofs*. We've sold many sets of proofs simply because I'd taken dozens of "minor" pictures the bride and groom didn't want to order as additional, full-priced prints, but which they still wanted nonetheless as less expensive Previews. Those sales add up to a not-so-small fortune.)

• *Miscellaneous*. This section is used to log sales which don't fit neatly into the above categories. For instance, frame sales. While we sell frames, with the Income Log I'm primarily interested in *photography* sales. I don't want to skew those averages with frames. If frames ever become a category I want to track separately, I'll give them their own row.

• *Reorders*. I define reorders as any sales which arrive *after* the Totals Letter has been sent to the bride. While I go after these sales, for the purpose of the Income Log, I consider reorders to be "found money". In earlier versions of this form, reorders were listed *above* the Bottom Line row. That made it difficult to "close" the Log, because reorders could keep coming in for months after the *original* series of finished prints were delivered. By separating reorders from these earlier orders, that's no longer the case.

Once the orders from the Totals Letter have been separated by source, it's time to start analyzing each of these groups individually. That's where the columns come in. Their role is to methodically break the information down, and display it in a format that makes sense.

• *Income*. This is the money an assignment generates. When totaled at The Bottom Line, the dollars shown will equal the total listed in the Totals Letter sent to the bride.

• *Cost*. This is where some of those dollars exit. Included are all *direct*, out-of-pocket expenses for producing a single wedding's products: film, proofs, prints, albums, folios, etc. Costs do *not* include such indirect expenses as studio rent, insurance, equipment, or anything else that may relate to the business, but not to this wedding. The Cost figures tell me how much money I'd have saved if I'd stayed home instead of going to the wedding.

• *Gross Profit*. After direct costs are paid, the money left over is *gross* profit. This is the money available for studio rent, insurance, equipment, etc. (Gross profit is not to be confused with *net* profit, which is the balance remaining after *all* a business' expenses have been paid. There's a BIG difference.)

• *Mark Up*. This is another way of viewing gross profits: as a percentage, rather than a dollar amount. For me, this is the most meaningful way of comparing wedding sales. It levels the playing field.

The numbers for the Income and Cost columns are gathered from the sales shown in the Totals Letter and invoices from suppliers. Once those numbers have been written down, the next step is some number crunching. The dollars listed in the Gross Profit column are found by subtracting Costs from Income. The Mark Up is figured by dividing Costs by Income. These steps are repeated for each row.

Once the numbers for each row are figured, next is finding the totals and percentages for each of the groups: Bridal Album as Booked, Bride and Groom's Totals, Parents' Totals, Family/Friend Totals, and Miscellaneous.

The Bottom Line amounts are a single figure for each column that applies to the wedding as a whole.

(Without getting into computers again, I want to add that if ever a job was designed for a computer, this is it. The Income Log is really nothing more than a spreadsheet program on paper. I have to admit that it's been a long time since I used a calculator to fill out the Income Log. With the computer, I just drop numbers into the Income and Cost columns, and the spreadsheet automatically computes the totals for Gross Profit, Mark Up, and the Bottom Line.)

Truth Or Consequences

I don't know about you, but I find the Income Log's numbers exciting. For any business, yours and mine included, these numbers are an unvarnished look at the wedding from a financial standpoint.

Over the years that I've been using the Income Log, it's been the one form that helps identify areas in my wedding photography which are either working especially well, or in need of an overhaul. Since the numbers don't lie, I've always found it worth my while to listen to what they are telling me.

Here are some examples of how a few numbers scribbled on the Income Log have helped me do a better job of taking pictures people are willing to buy:

• An early lesson learned from studying the Income Log was not to book small weddings, then offer to stay longer, for a low hourly rate, hoping that the extra pictures would lead to added sales. I tested this approach early in my career, kidding myself into believing it was working out to my benefit.

The Income Log proved that this theory wasn't supported by the facts. What I saw on the Log was that the added sales just about covered my costs for film, processing, and proofs. I was essentially working for nothing. This realization made me much more willing to raise my "additional time" charges to a realistic rate. If the bride and groom didn't want to pay, then I knew I wasn't losing anything by packing up and going home.

• Another valuable realization was to *not* spend *all* my time at a wedding photographing the bridal couple. As hard as I tried, I saw firsthand that

running rolls of film and producing countless pose variations didn't automatically lead to increased sales.

The Income Log told the story. Its message: most (but not all) Bridal Albums' sales top out not far past the originally booked coverage. It was an uphill battle to add to bride and grooms' purchases by offering more choices; once they'd chosen the pictures they liked, most additional sales came from their orders for *additional copies of prints they had already chosen for their album*. Giving them an infinite variety of choices of pictures of themselves didn't translate into added sales. It did, however, make a big difference in my costs.

The Income Log showed me how to better use my time. One look at the Mark Up percentages jumping off the page for Parents' Totals and Family/Friends—almost anyone *but* the bride and groom—and I knew where to invest my "extra" time. Other people wanted pictures, and the prices they paid brought in some of the highest profits. It was a no-brainer.

• The Income Log also gave me the confidence to take the last idea one step further. Once I started paying more attention to these "other people", I saw that they were anxious to take advantage of having easy access to professional photography. Up to this point, my pictures of these folks amounted to little more than standing them in front of a potted plant, then taking what amounted to a professionally priced snapshot. Some bought, but I suspected that better quality would produce higher sales.

Again, the Income Log provided the justification I needed to upgrade the photography—and my attitude. I purchased a portable canvas background, added some umbrellas and studio lights, and commenced making it a policy to set up a mini-studio at every wedding I photographed. The payoff was immediate. These sideline photographs have become as important to my bottom line as the pictures I produce for the bride and groom. Oftentimes, even more so.

• Perhaps the Income Log's greatest benefit has been the way it breaks a wedding down into bite-sized pieces. I can see the forest—and the trees. Rather than subtracting *total* costs from *total* income and coming up with a single overall figure, the Log has forced me to pay individual attention to each area of the wedding. Even if *overall* sales are good, the Log will clearly point out which individual areas are yielding the highest sales, and which are barely pulling their own weight.

It's amazing how fast the dollars can add up if all groups are hitting on all cylinders. A few minutes spent tracking down a few relatives, taking a pleasant picture or three—and, *BINGO!*, the order total is increased by $100+. With no Income Log prodding me, who knows whether I would have taken those few extra pictures...or been seen pushing my way to the food table to commandeer a cheeseball. (If so, that would have been one expensive snack.)

The net result of these, and other, Log Lessons has been that filling in those rows and columns has become a major highlight of any wedding. It's a game, but it's one I play to win. I want to know how I scored, and whether or not I've raised my batting average.

Reality Check

At the bottom of the Income Log, in the lower right-hand corner, you'll notice the area headed, "Hours...". No matter what other numbers are written anywhere else on the Log, it's the number written in the box labeled *Hourly Gross Income From This Wedding* that is the true measure of how well a wedding has panned out. That number is the *final* score.

While I don't believe it's necessary to track time to the minute, I do want to know, on an hourly basis, whether the wedding was worth my time—or if I would have been better off booking studio sittings. Or staying home. Or *anything!* Breaking an entire wedding order down into a net hourly rate is the best indicator I've found for keeping me honest with myself about how much each assignment is generating in relation to the number of total hours I've invested.

This little box also does a superlative job of providing an absolute reference point I can use for comparing one wedding against another. Not surprisingly, some of my top scoring weddings have been short, intense affairs where a lot of action was packed into a very few hours. Even though the total sales may not be among my highest ever, the high hourly gross tells me very clearly that great things do come in small packages.

Inspiration Point

The Notes area at the bottom of the Income Log is important in a different way. As I'm going over the Log, filling in numbers, and thinking about the wedding, this is where I jot down any ideas that come to mind...and which I may forget if I don't write them down.

I'm looking for *patterns*. At one wedding, for example, I may try something new just to see what happens. If it works, it may be a fluke—or it may be the next "sure thing". *Inquiring minds want to know.* By tracking these ideas, and making a habit of monitoring how well they pan out over time, I can zero in on picture ideas which I know should please people enough that they'll buy prints. And, since selling prints is why I'm attending the wedding, I believe I'm doing people a service by uncovering these golden shots, rather than wasting their time and mine taking pictures nobody wants badly enough to buy.

Sum Of All The Parts

If you agree that it's wise to pay just as much attention to your financial picture as to your photographs, I think you'll find using the Income Log a very productive use of your time. In fact, a very strong case could be made for the idea that

the Income Log is your best true indicator of how well you've done managing all the other policies and procedures discussed in this book.

If you've set up your policies well, done a good job of handling the contract, taken the time to explain important details to your brides, and are generally doing "everything right", then you'll see only open road ahead for you and your business. On the other hand, if you discover various roadblocks which are limiting how hard you can push down on your business' accelerator, you'll want to make it a top priority to move those problems out of your way.

As a wedding professional, your real job, then, is to scan your entire business landscape, looking for areas which are holding back the numbers on the Income Log. Improve any one of them, and your "score" will start moving up. Commit yourself to continually improving *all* of them, and your ratings will surge. You'll find yourself moving to the head of the pack not only in terms of earning power, but also in the positive way your community views you and your photography.

As I said, this is exciting stuff. And believe me, the higher those numbers go, the more exciting it gets.

Conclusion

About now, I hope you're saying to yourself, "Gee, Steve, all those ideas you've been throwing around about contracts and policies don't seem all that complicated. *I can do that.*"

And, you'd be right. You can do it. In fact, I think you'll be surprised at how un-difficult it is setting up a system of contracts, forms, and other paperwork which will clear up some of those persistent and nagging problems you may be having.

With this book, I've tried to make that process easier for you. I wanted to provide ideas that work, present them in a ready-to-use format—and give you the tools you need to quickly bypass a ton of expensive mistakes. Knowing firsthand how effective the policies and forms we've been discussing have been for my studio, I have no doubts that you'll be able to put these policies to good use in your business.

Universal Questions. Customized Answers.

Even though this book is meant to make getting your policies in place easier, that doesn't mean you don't have questions about how, *precisely*, another photographer's ideas and answers can be applied to *your* operation, in *your* community, with *your* brides. Those kinds of questions are not unreasonable.

In fact, they're universal. *Every* wedding photographer asks them.

I know, because over the years I've asked them all myself. Back in the mid-1970's, when I was paying my dues in this industry, and questioning which policies and ideas would work best for me, I was constantly surprised at how *obvious* the answers were...*once they were staring me in the face.* I was always looking for ideas I could pick up from other photographers—and I was particularly pleased when I could learn from their mistakes, rather than making them on my own. Even if I later modified and reworked their ideas to better fit my way of working, at least in the meantime they had provided something I could use. That was a lot better than having nothing.

This book should play the same role for you. Although I'm sure there are differences between how you and I approach some situations in our wedding businesses, I know that 95% of what works for me can be pulled from these pages, dropped "as is" into your business, and then used to start producing positive results quickly. (The brides I work with can't be *that* different from those in your area!)

At the least, you'll have a head start in building your own customized solutions.

At most, the problems you had yesterday will be history by this time tomorrow, and you won't have to think about them anymore.

The Next Move Is Yours

Still, it's up to you to make it happen. Whether or not you use my policies word for word, or take off in a completely different direction, I can guarantee that after you've seen the amazing power that accompanies a solid set of policies set down on paper, ready to sign, you'll wonder how you ever got along without it.

But don't put it off. Don't wait until you're "in the mood" before you begin adapting these ideas to your business. The best thing you can do is just sit down, right now, and get started. Turn on the computer. Sharpen those pencils. Do whatever it takes to begin identifying the ideas you want to use, then get them on forms with your name at the top.

It shouldn't take you more than a few hours to produce a set of forms which are ready to use with your next round of weddings.

Once you see how much easier your business life becomes when you've got those pieces of paper to point to, the worst part of the whole process will be the beating you'll inflict upon yourself for not getting started sooner.

Take my word for it: it's worth the effort.

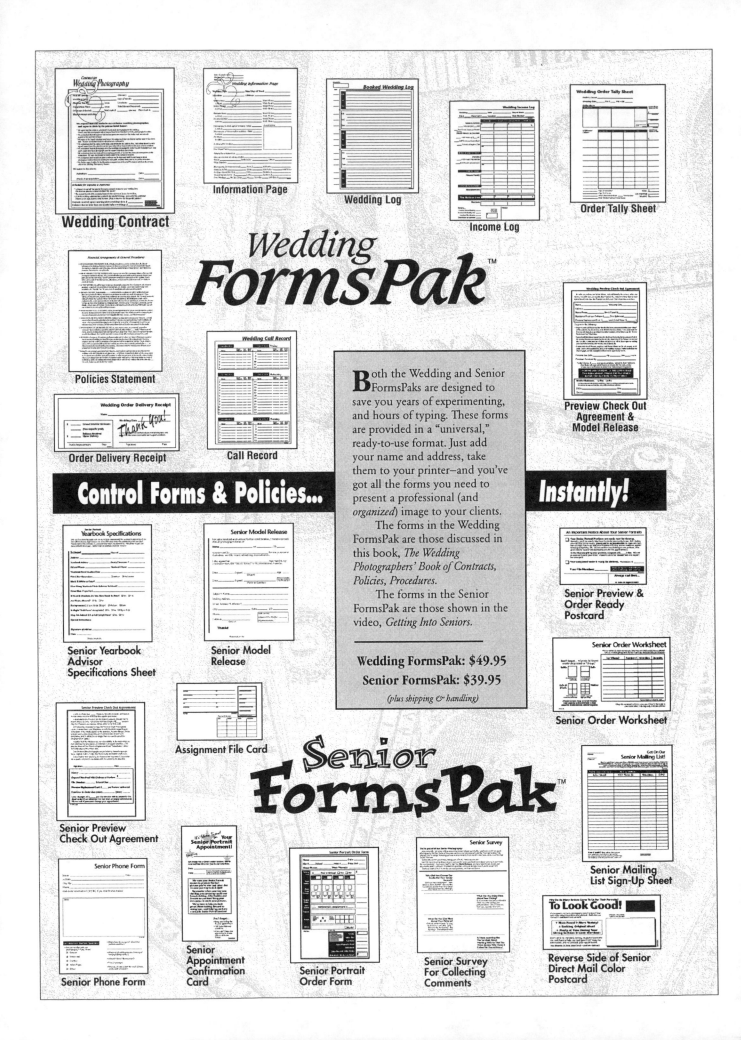

Wedding FormsPak™

Wedding Contract

Information Page

Wedding Log

Income Log

Order Tally Sheet

Policies Statement

Call Record

Preview Check Out Agreement & Model Release

Order Delivery Receipt

Control Forms & Policies... Instantly!

Both the Wedding and Senior FormsPaks are designed to save you years of experimenting, and hours of typing. These forms are provided in a "universal," ready-to-use format. Just add your name and address, take them to your printer—and you've got all the forms you need to present a professional (and *organized*) image to your clients.

The forms in the Wedding FormsPak are those discussed in this book, *The Wedding Photographers' Book of Contracts, Policies, Procedures.*

The forms in the Senior FormsPak are those shown in the video, *Getting Into Seniors.*

Wedding FormsPak: $49.95

Senior FormsPak: $39.95

(plus shipping & handling)

Senior Yearbook Advisor Specifications Sheet

Senior Model Release

Senior Preview & Order Ready Postcard

Senior Order Worksheet

Senior Preview Check Out Agreement

Assignment File Card

Senior FormsPak™

Senior Phone Form

Senior Appointment Confirmation Card

Senior Portrait Order Form

Senior Survey For Collecting Comments

Senior Mailing List Sign-Up Sheet

Reverse Side of Senior Direct Mail Color Postcard